# new diningroom design

daab

| | |
|---|---|
| **Air Projects / Inés Rodríguez Mansilla** \| Apartment Reina Victoria | 8 |
| **Air Projects / Inés Rodríguez Mansilla** \| Loft Vapor Llull | 12 |
| **Air Projects / Raül Campderrich Pons** \| House in Girona | 16 |
| **Alberto Martínez Carabajal** \| House Girona | 20 |
| **Alfons Soldevila Barbosa** \| Tiana-Alella House | 24 |
| **Ars Spatium Space Design** \| Apartment Collserola | 28 |
| **AV62 Arquitectos** \| Apartment Bruc | 32 |
| **AV62 Arquitectos** \| Two Houses in Plentzia | 36 |
| **BMMC Architects & Engineers / Claudia Montevecchi** \| Carlo and Lella's House | 40 |
| **Cho Slade Architecture** \| Smith Loft | 44 |
| **Cho Slade Architecture** \| Noho Loft | 48 |
| **Claesson Koivisto Rune** \| Kjell Nordström Residence | 52 |
| **Claudi Aguiló Riu, Xavier Vendrell Sala** \| Tamarit-Vendrell House | 56 |
| **Co Twee** \| Sullo Shelde House | 60 |
| **David Luck Architecture** \| Douralis House | 64 |
| **David Maturen, Arantxa Garmendia** \| Penthouse | 68 |
| **Emanuele Tettamanzi** \| Apartment in Cantù | 74 |
| **Eriksson Thomas Arkitekter** \| House in Karlskrona | 78 |
| **Giorgio Marè** \| White Loft | 82 |
| **GMC Interiores** \| Custom-made Residence | 86 |
| **Graft** \| Loft Zeal | 90 |
| **Greek** \| House in Esplugues | 94 |
| **Gustavo Barba** \| Fusina Street Flat | 98 |
| **Jaime Gaztelu** \| Gutiérrez Apartment | 102 |
| **Joan Bach** \| Fraternitat Duplex | 106 |
| **Lucia Bisi, Elena Lazzeri, Maurizio Monteforte** \| Caproni Loft | 110 |
| **MAP Arquitectos** \| House in Begur | 114 |
| **Mariana Castro, Nacho Martí** \| MC Flat | 118 |
| **Massimo Sottili** \| Archetipo Loft | 122 |
| **Maximià Torruella Castel** \| Apartment in Barcelona | 126 |
| **Minim** \| House in Fatarella | 130 |
| **Moneo Brock Studio** \| Hudson Street Loft | 134 |
| **Moneo Brock Studio** \| Greenwich Street Loft | 138 |
| **Nosuch** \| Apartment in Stockholm | 142 |
| **Oriol Rosselló Viñas** \| Prada House | 146 |
| **Ramón Rodríguez** \| Loft Duplex Cortines | 150 |
| **Redmark & Partners, Marco Michele Rossi** \| Alessandro Betteni Loft | 154 |
| **Sepllobetarquitectes** \| Aida and Jordi's House | 158 |
| **Silvia Via** \| Loft One | 162 |
| **Simon Conder** \| Garden Room in North London | 166 |
| **Studio Architetti Associati** \| House in San Leo | 170 |
| **Studio Associato Falconi** \| Bonomi House | 174 |
| **Studio Job** \| Studio Job | 178 |
| **White Architects White Design** \| Optibo | 182 |

Si bien antaño se prefería una estricta división espacial entre la cocina, el salón y el comedor, hoy en día no es raro que la zona destinada para comer esté integrada en la sala de estar. Esta concepción abierta proporciona un espacio amplio que fomenta la convivencia diaria. La forma y el tamaño de la mesa resultan fundamentales; tanto como la elección de una iluminación adecuada. Si el espacio disponible es limitado, suele ser más recomendable elegir una mesa redonda sin excesivos ornamentos combinada con una lámpara circular. Si, por el contrario, el espacio y la mesa son alargados, la iluminación ideal se obtiene por medio de varias lámparas instaladas en hilera. Asimismo, para crear ambientes diáfanos y claros, es preferible utilizar materiales como el cristal o el PVC.

Alors que traditionnellement, la cuisine est séparée de la salle à manger et du salon, ces derniers temps, la tendance est d'intégrer davantage le coin repas à l'espace de vie. L'ouverture de l'espace qui en découle permet de créer des pièces plus généreuses et conviviales. La taille et la forme de la table jouent aussi un rôle essentiel au même titre que le choix de l'éclairage. Si l'on ne dispose que d'un petit espace, il sera préférable de combiner une table ronde aux lignes sobres avec une lampe circulaire. Au-dessus d'une table tout en longueur, une enfilade de lampes permettra un éclairage optimal. Pour créer des espaces intérieurs clairs et baignés de lumière, l'idéal sera d'utiliser certains matériaux, à l'instar de verre ou de PVC.

Mentre nel passato si era soliti creare una divisione spaziale tra cucina, soggiorno e sala da pranzo, oggi si tende ad integrare sempre di più la zona pranzo nello spazio abitativo. Gli ambienti delineati in modo aperto creano così una superficie dalle dimensioni generose che favorisce la convivialità. Fondamentali sono anche la forma e il colore del tavolo e la scelta dell'illuminazione. Se lo spazio disponibile possiede dimensioni ridotte, è preferibile combinare un tavolo rotondo senza decorazioni con un lampadario circolare; se il tavolo è molto lungo, si ottiene un'illuminazione ottimale con una serie di luci allineate. Per creare interni particolarmente luminosi si può ricorrere a materiali come vetro o PVC.

Wurde ursprünglich eine räumliche Trennung von Küche, Wohn- und Esszimmer vollzogen, so wird der Essbereich heutzutage vermehrt in den Wohnraum integriert. Die auf diese Weise offen gestalteten Bereiche schaffen eine großzügige Fläche für ein geselliges Zusammensein. Entscheidend sind auch Form und Größe des Tisches sowie die Wahl der Beleuchtung. Steht nur ein begrenzter Raum zur Verfügung, so sollte man einen schnörkellosen runden Tisch mit einer kreisförmigen Lampe kombinieren. Ist der Tisch sehr lang, so erzielt man eine optimale Beleuchtung durch mehrere, in einer Reihe installierten, Lampen. Um besonders helle und lichtdurchflutete Innenräume zu kreieren, verwendet man am besten Materialien wie Glas oder PVC.

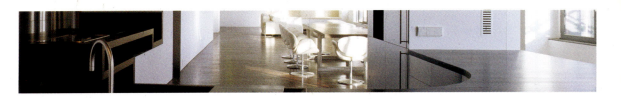

While a spatial division between kitchen, living room and dining room was originally implemented, today an eating area is often integrated into the living area. Interior areas designed in this way are open and create large spaces, which promote social interaction. Decisive here is the shape and size of the table, as well as the choice of lighting. If there is a smaller space available, a simple and unadorned round table combined with a round lamp suggests itself. If the table is very long, optimal lighting can be achieved by several lamps installed in a line above. To create an especially bright illuminated interior space, it is best to use materials like glass or PVC.

**Air Projects/Inés Rodríguez Mansilla | Barcelona, Spain**
Apartment Reina Victoria
Barcelona, Spain | 2003

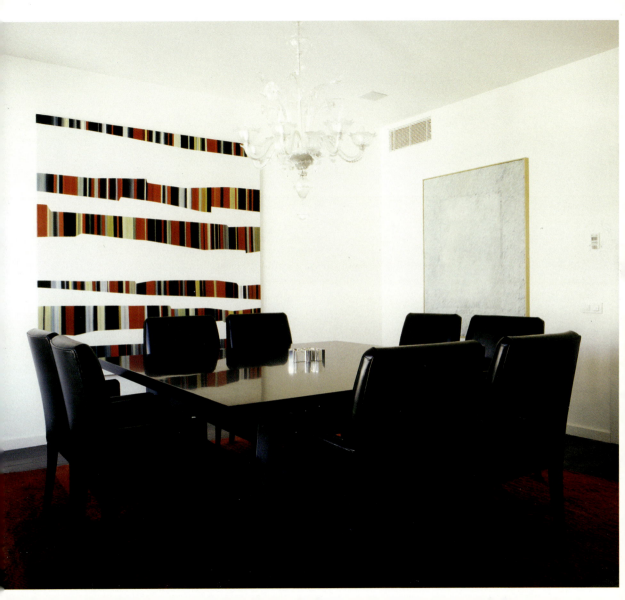

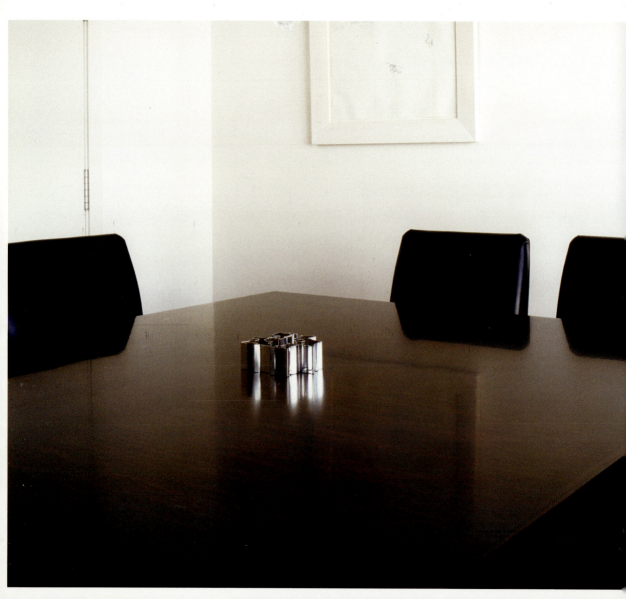

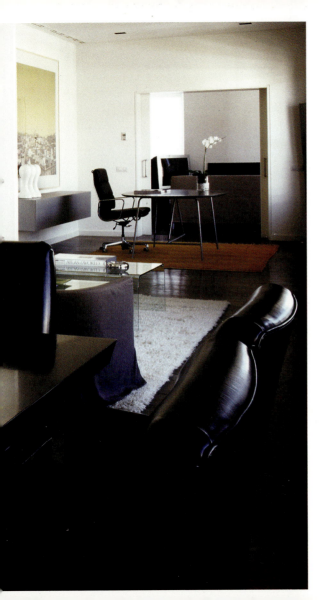

**Air Projects/Inés Rodríguez Mansilla | Barcelona, Spain**
Loft Vapor Llull
Barcelona, Spain | 1999

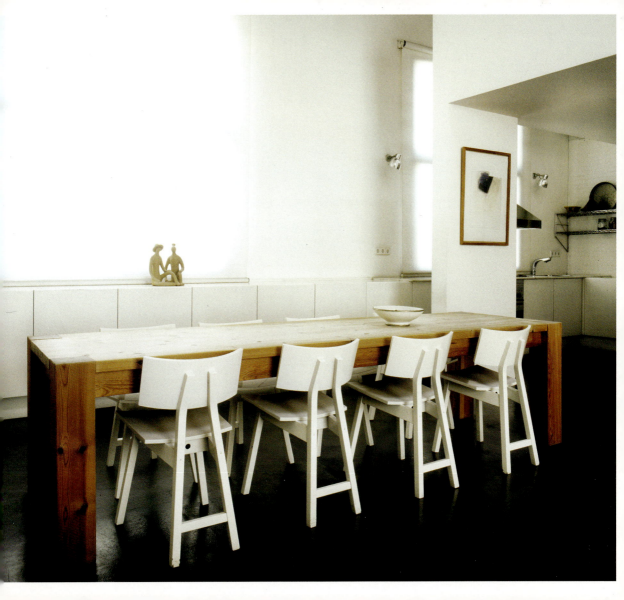

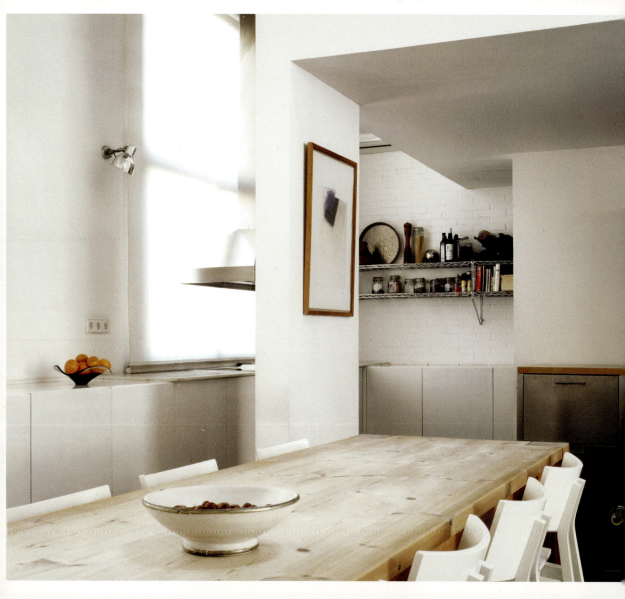

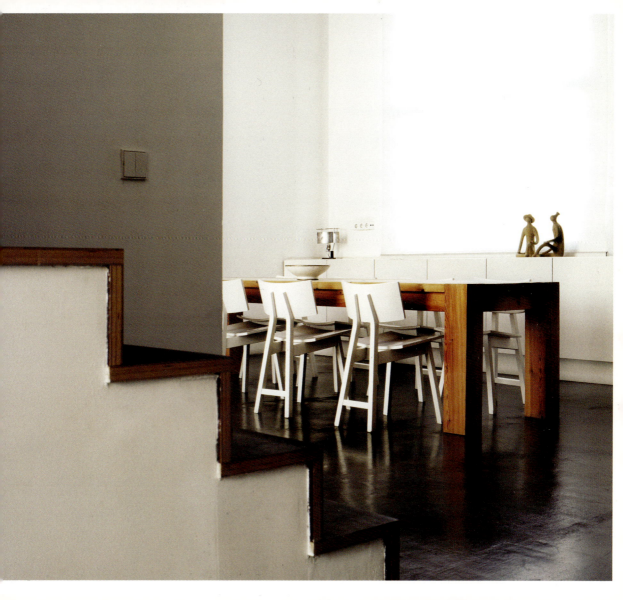

**Air Projects/Raül Campderrich Pons | Barcelona, Spain**
House in Girona
Girona, Spain | 2001

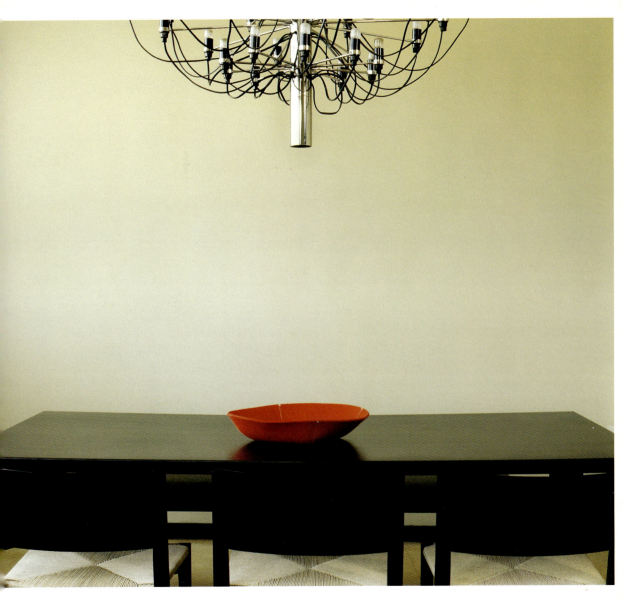

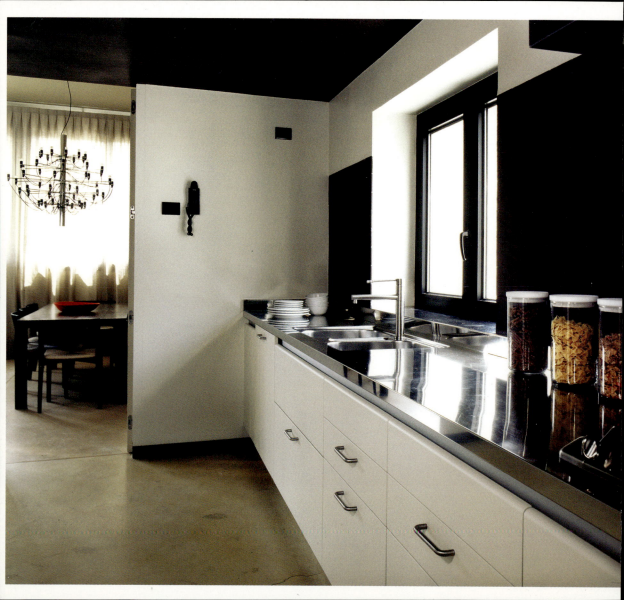

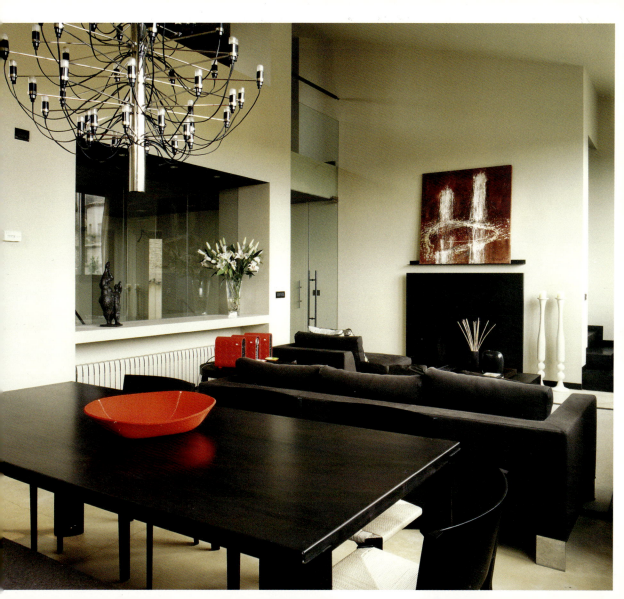

**Alberto Martínez Carabajal | Barcelona, Spain**
House Girona
Sitges, Spain | 2001

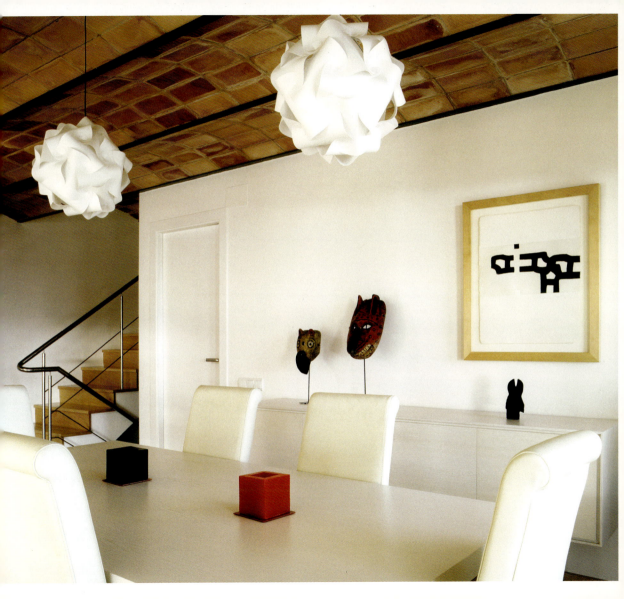

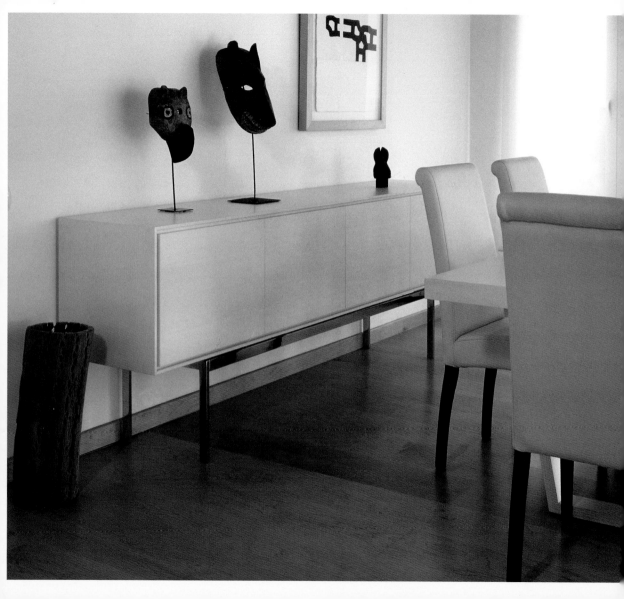

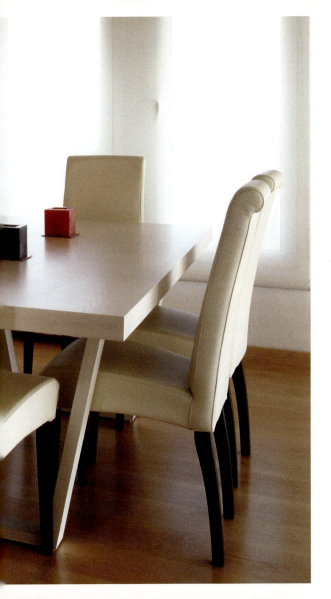

**Alfons Soldevila Barbosa | Badalona, Spain**
Tiana-Alella House
Tiana, Spain | 2002

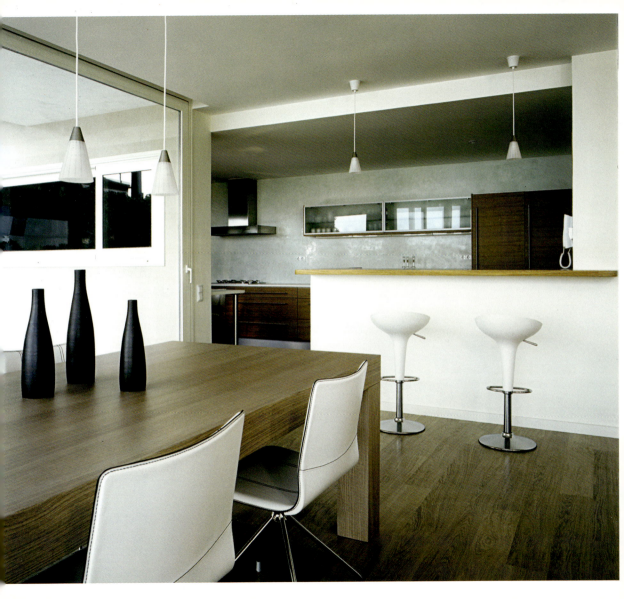

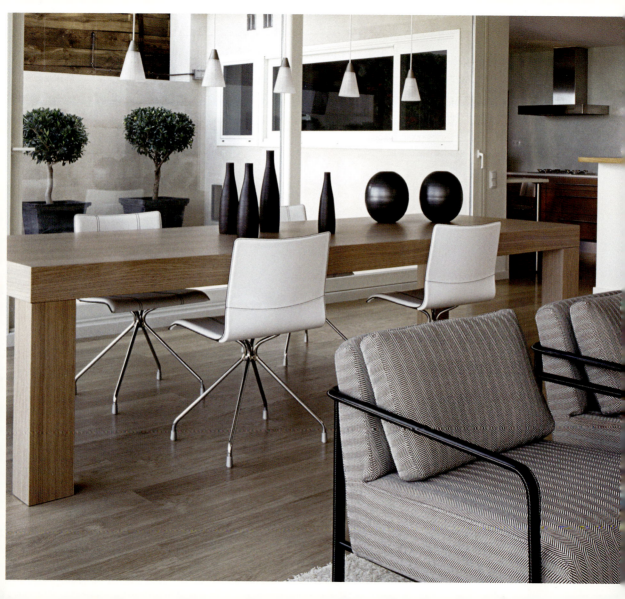

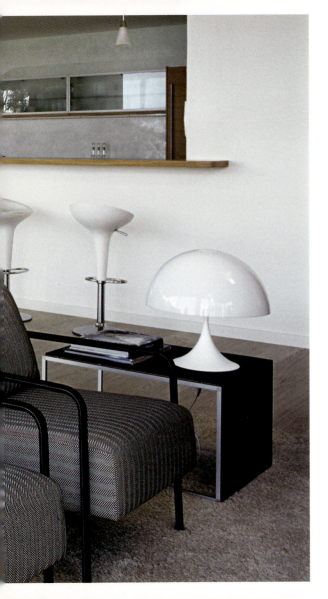

**Ars Spatium Space Design | Barcelona, Spain**
Apartment Collserola
Barcelona, Spain | 2004

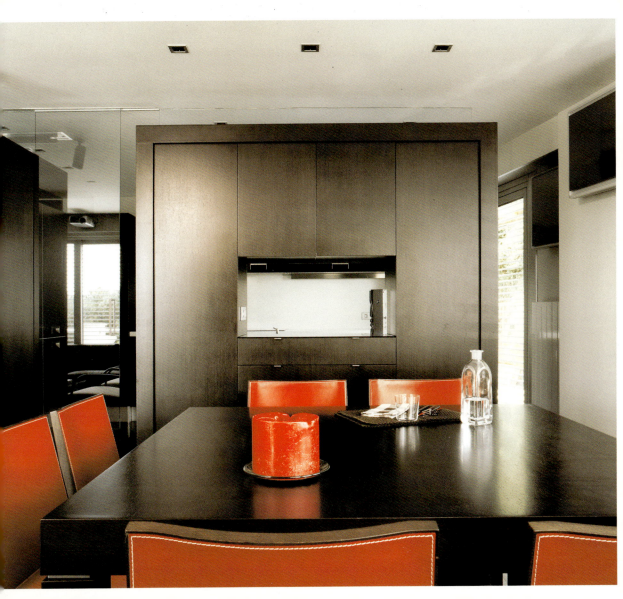

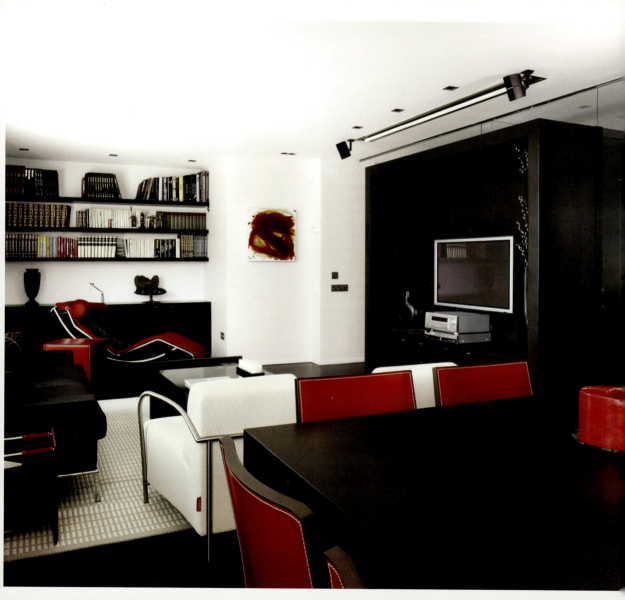

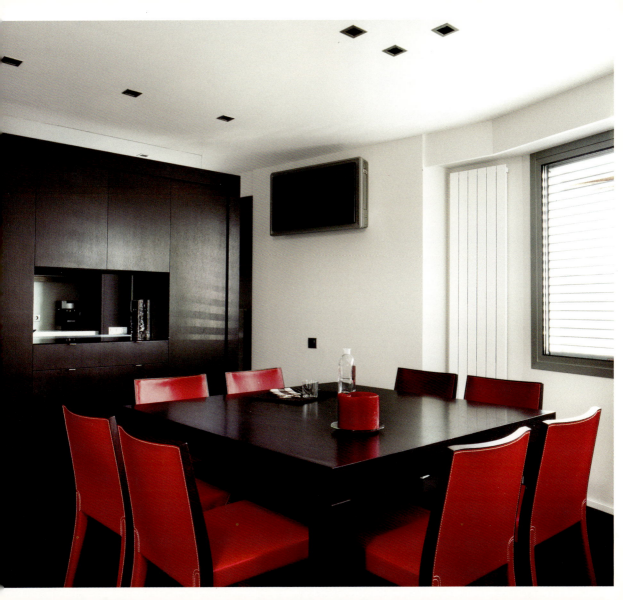

**AV62 Arquitectos | Barcelona, Spain**
Apartment Bruc
Barcelona, Spain | 1997

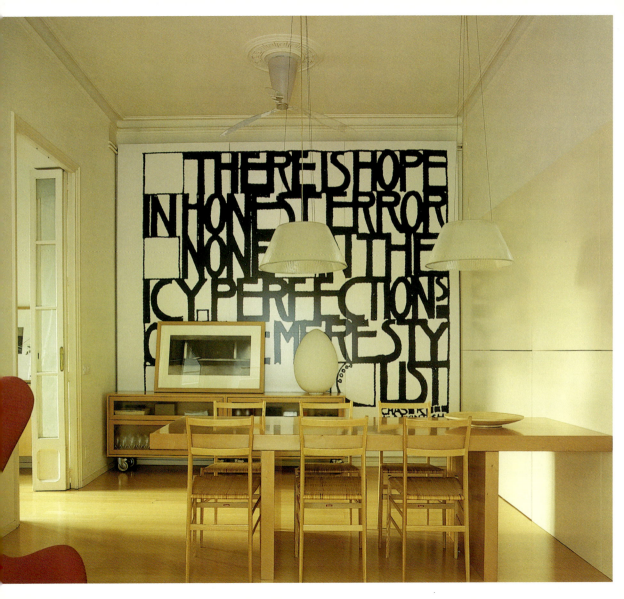

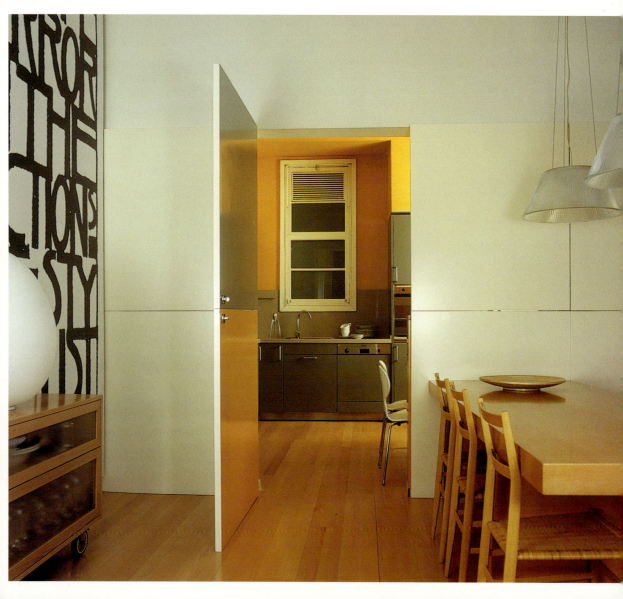

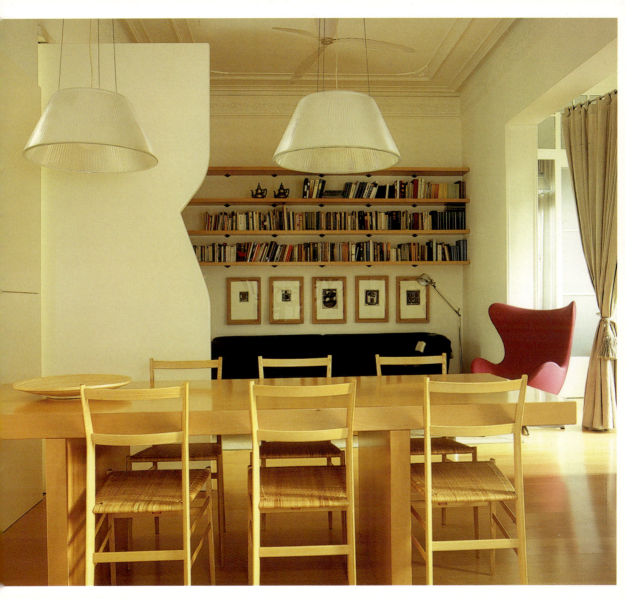

**AV62 Arquitectos | Barcelona, Spain**
Two Houses in Plentzia
Plentzia, Spain | 2003

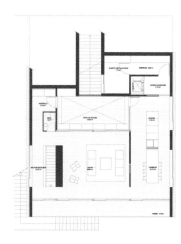

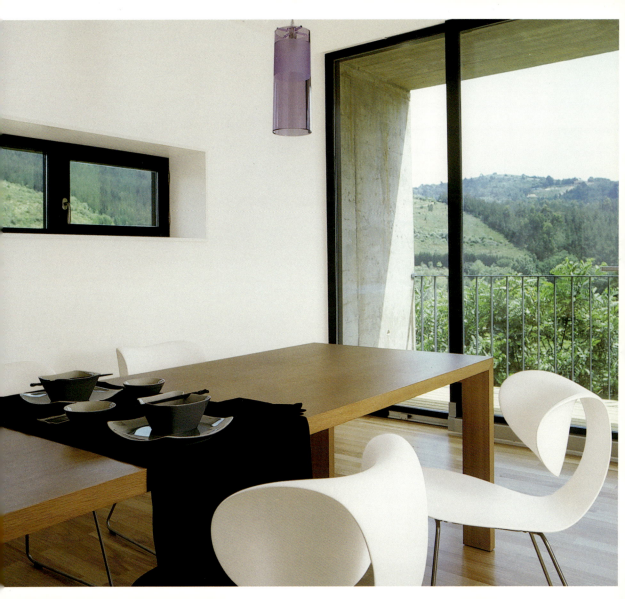

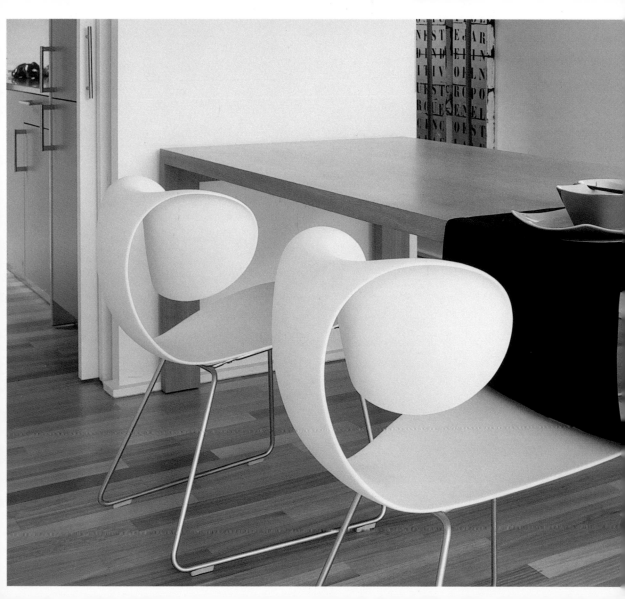

**BMMC Architects & Engineers/Claudia Montevecchi | Milan, Italy**
Carlo and Lella's House
Milan, Italy | 2004

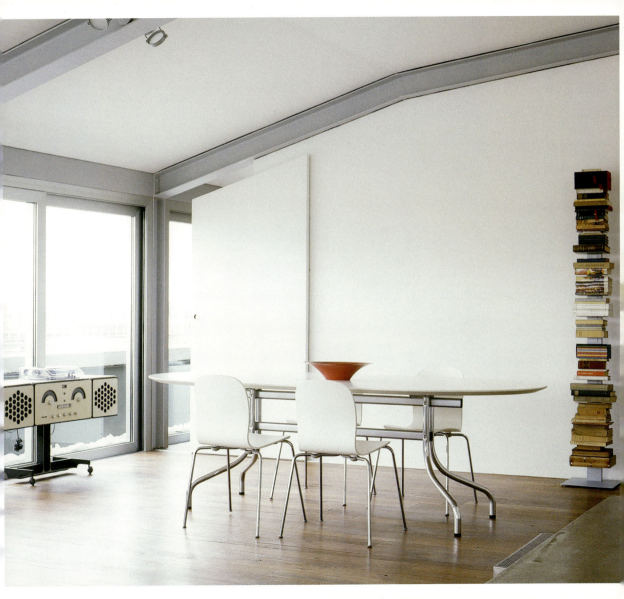

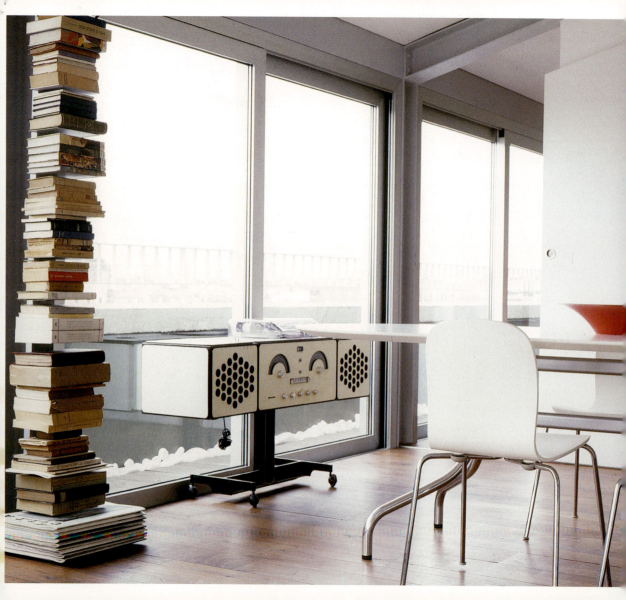

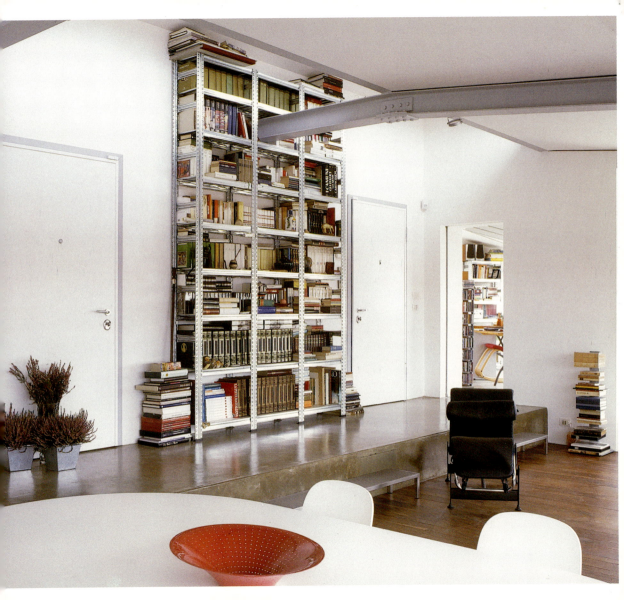

**Cho Slade Architecture | New York, USA**
Smith Loft
New York, USA | 2001

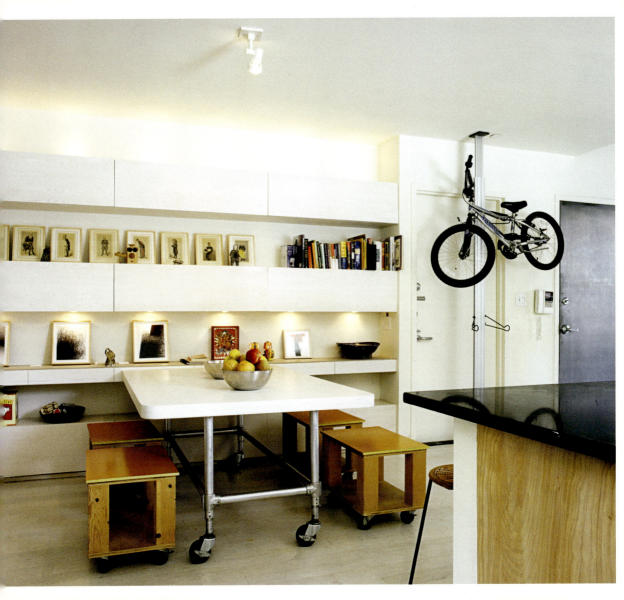

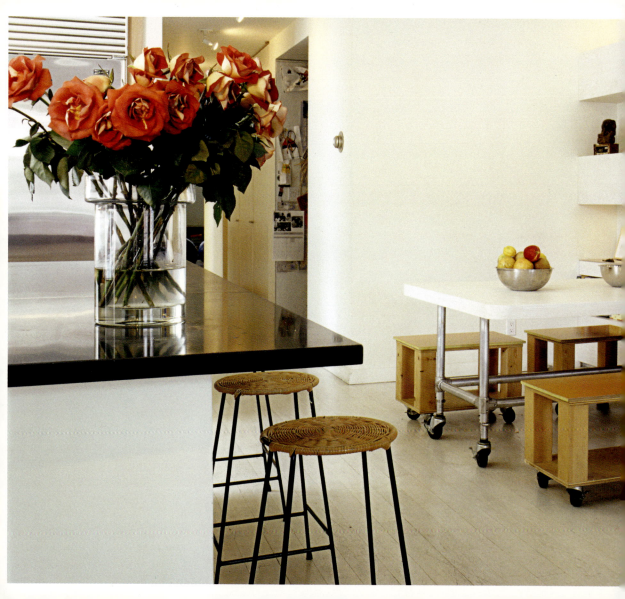

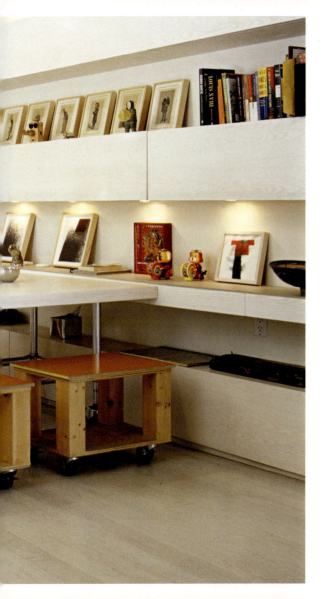

**Cho Slade Architecture | New York, USA**
Noho Loft
New York, USA | 2004

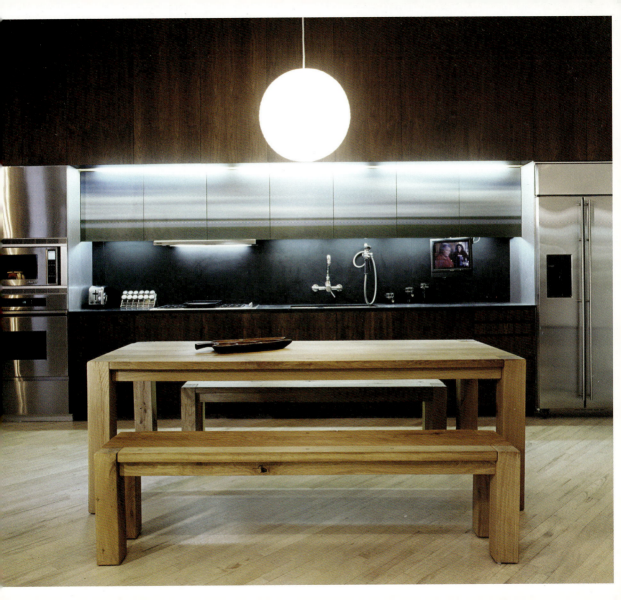

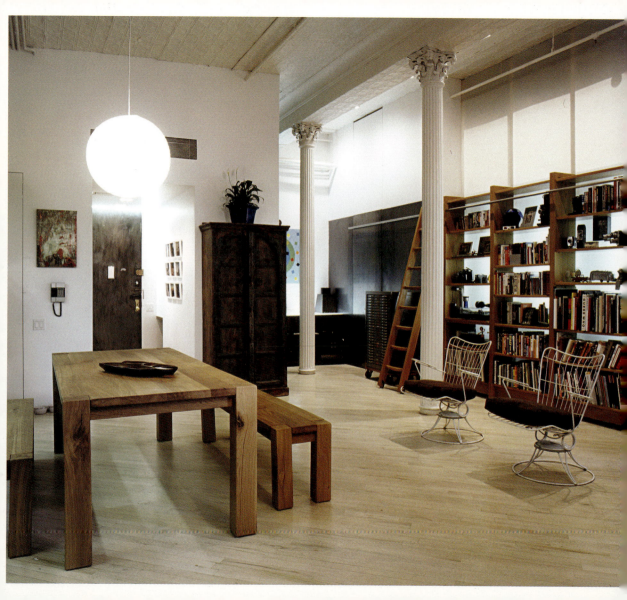

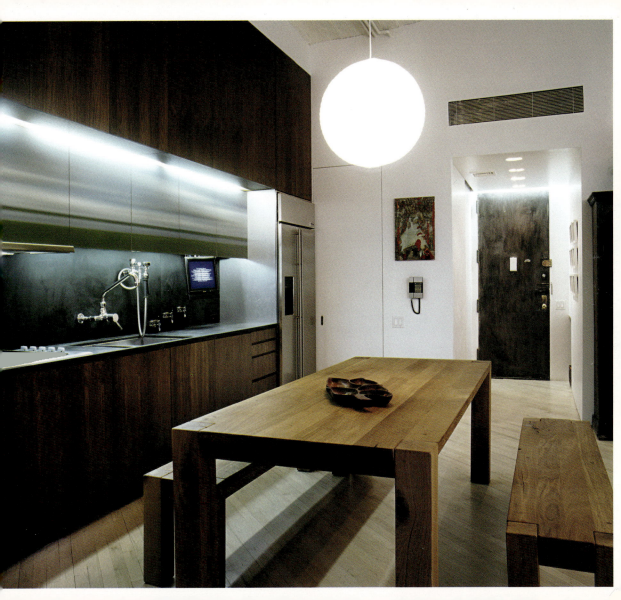

**Claesson Koivisto Rune | Stockholm, Sweden**
Kjell Nordström Residence
Stockholm, Sweden | 2005

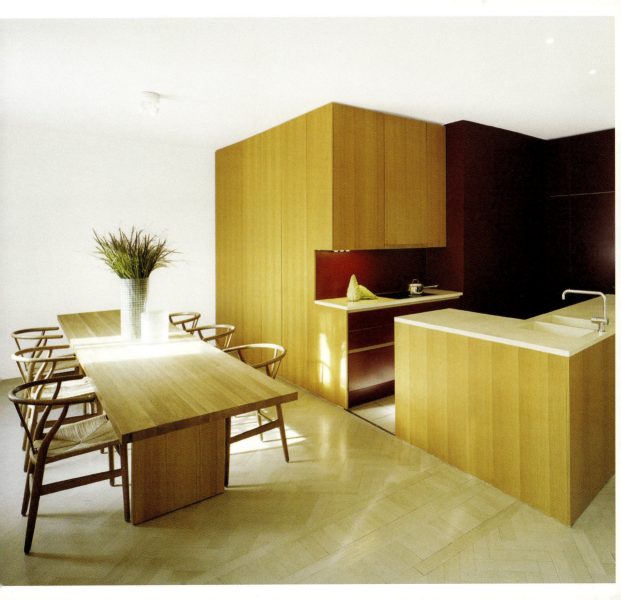

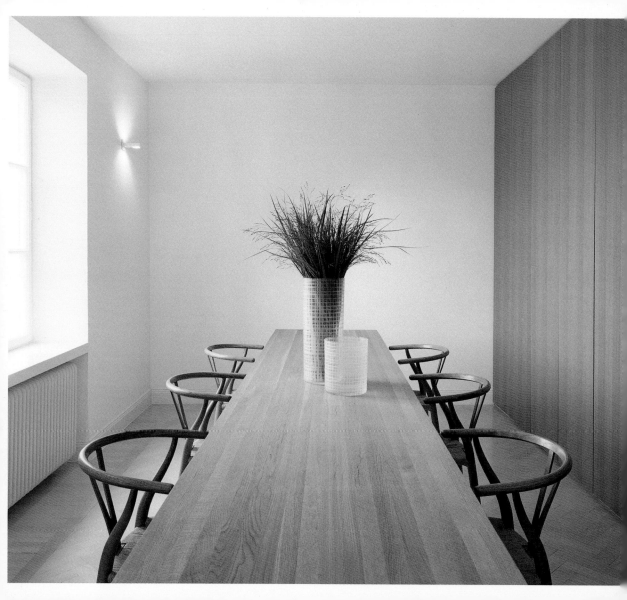

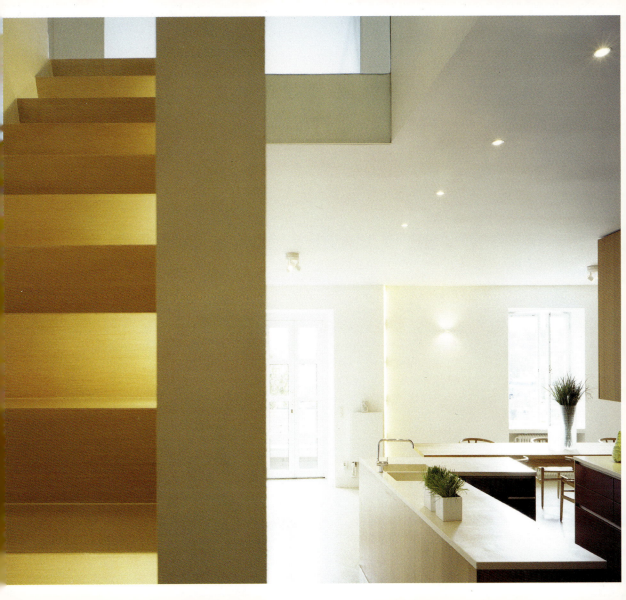

**Claudi Aguiló Riu, Xavier Vendrell Sala | Barcelona, Spain**
Tamarit-Vendrell House
Tarragona, Spain | 2004

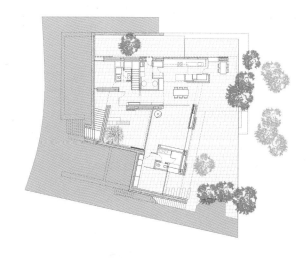

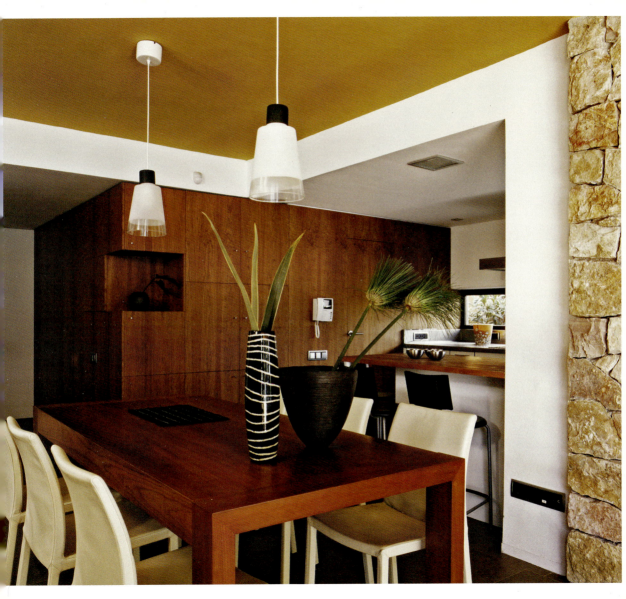

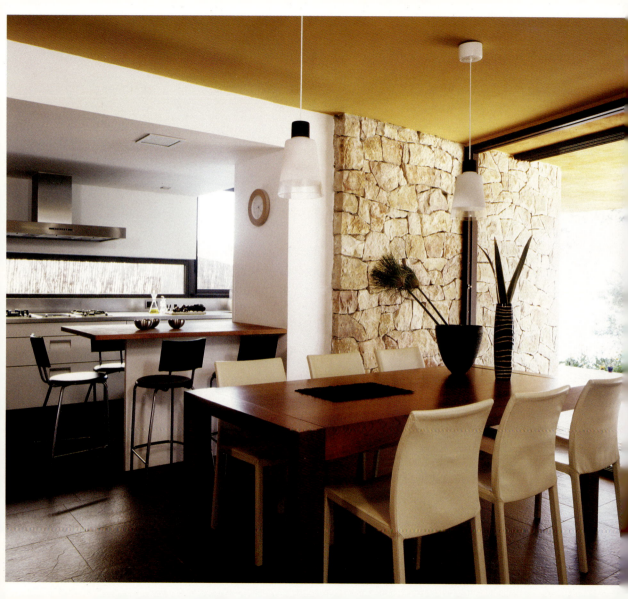

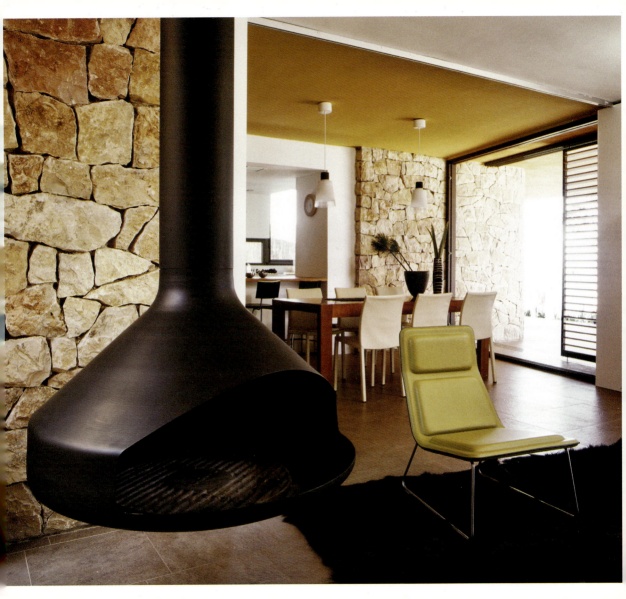

**Co Twee | Antwerp, Belgium**
Sullo Shelde House
Antwerp, Belgium | 2001

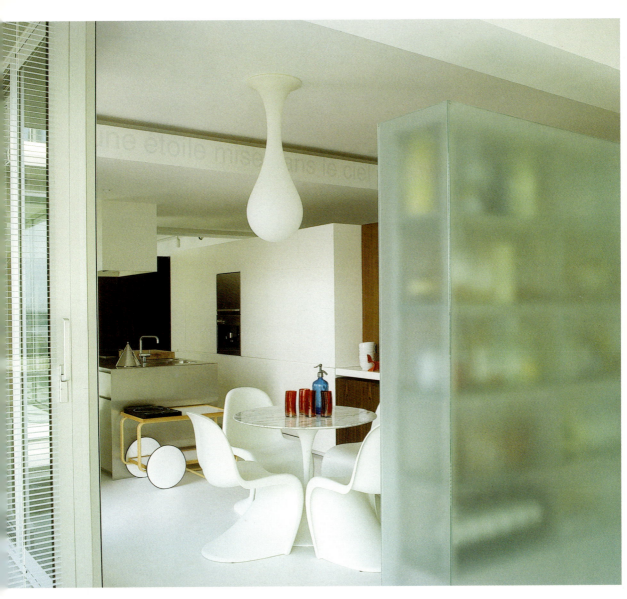

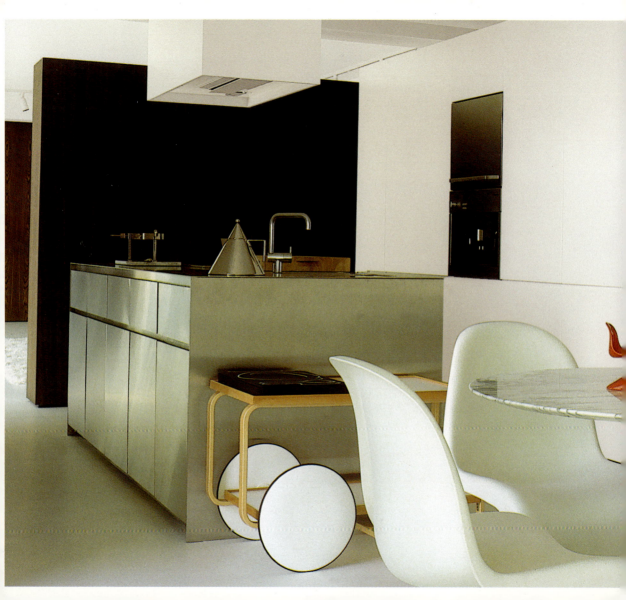

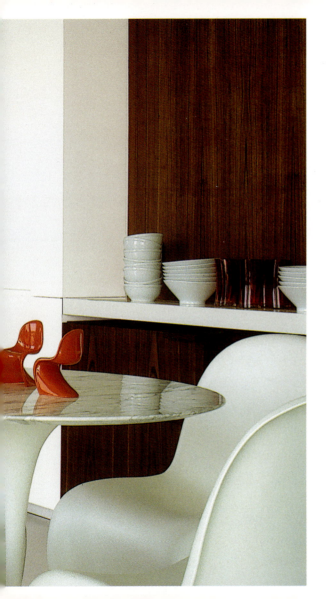

**David Luck Architecture | South Yarra, Australia**
Douralis House
Brunswick, Australia | 2004

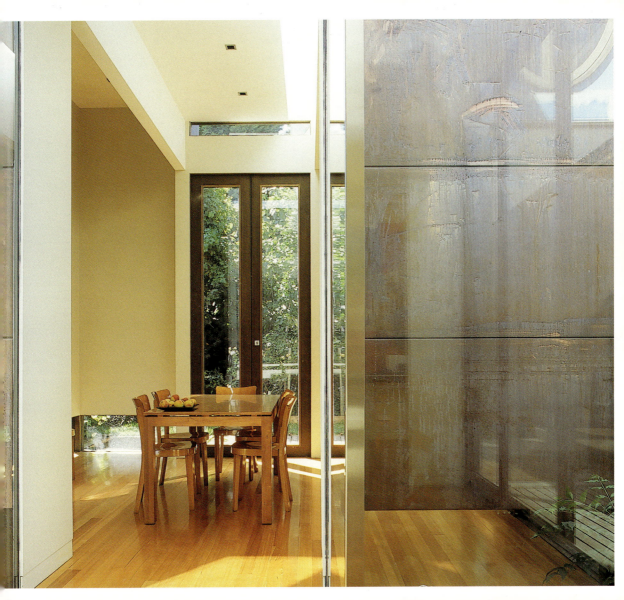

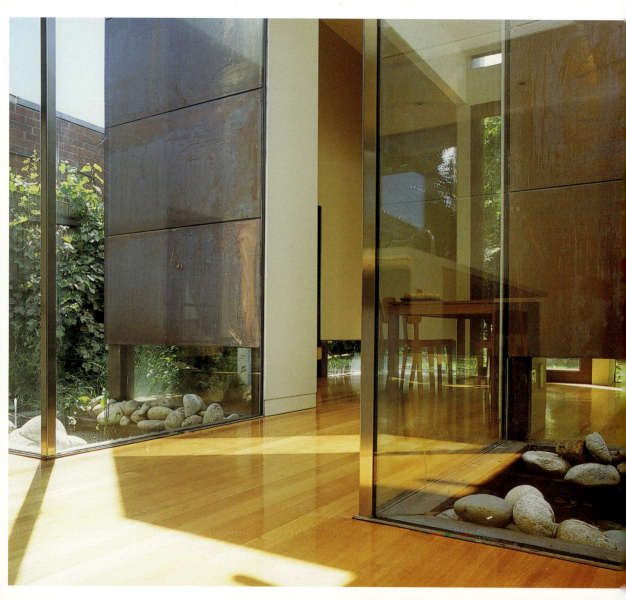

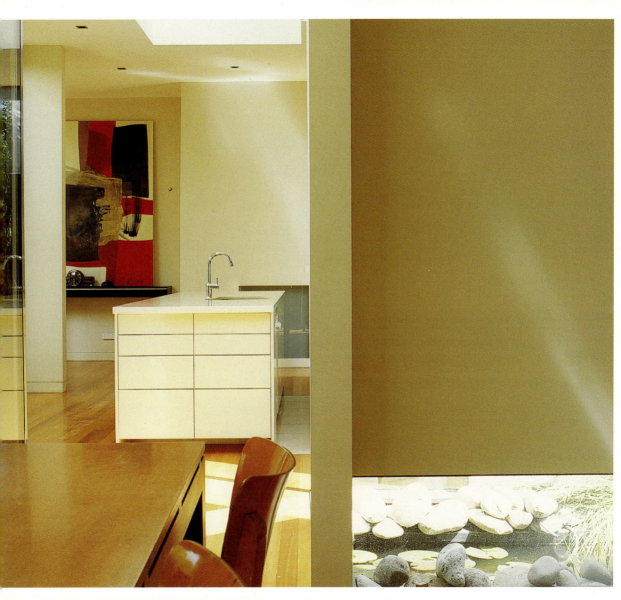

**David Maturen, Arantxa Garmendia | Zaragoza, Spain**
Penthouse
Zaragoza, Spain | 2001

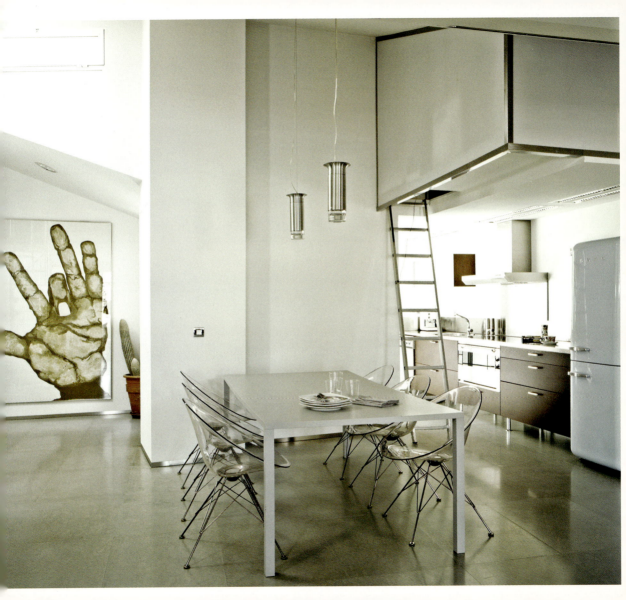

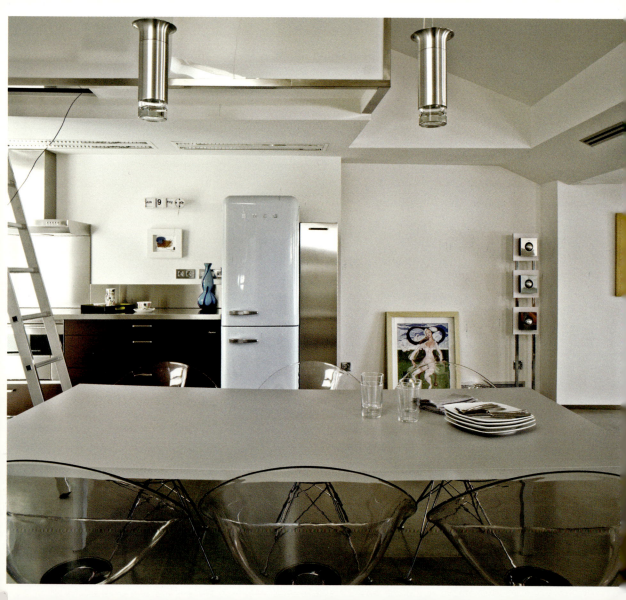

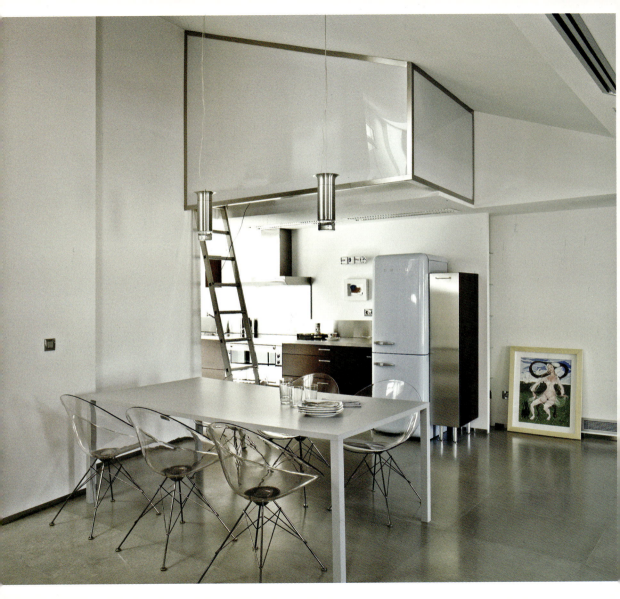

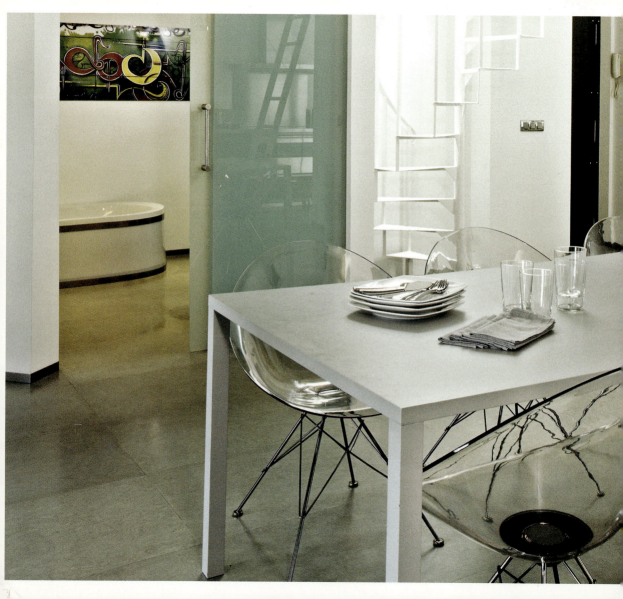

**Emanuele Tettamanzi**
Apartment in Cantù
Milan, Italy | 2001

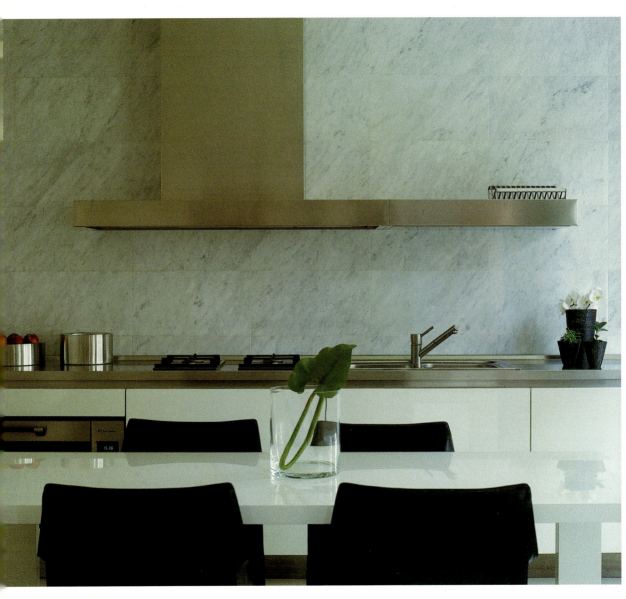

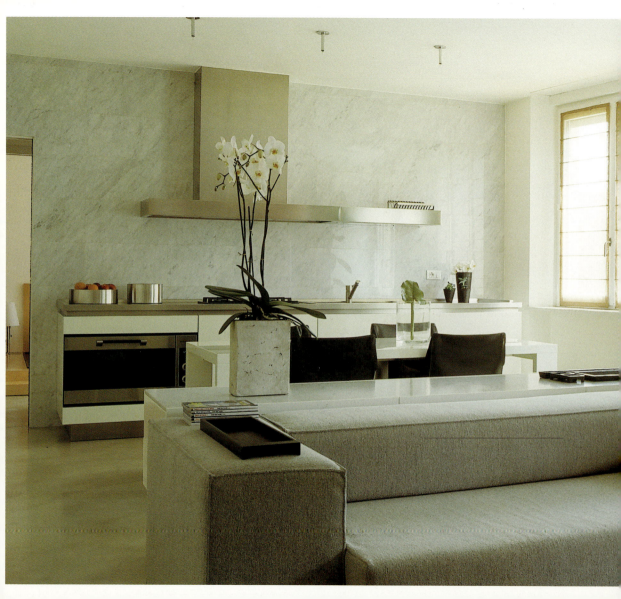

**Eriksson Thomas Arkitekter | Stockholm, Sweden**
House in Karlskrona
Sturkö, Sweden | 2001

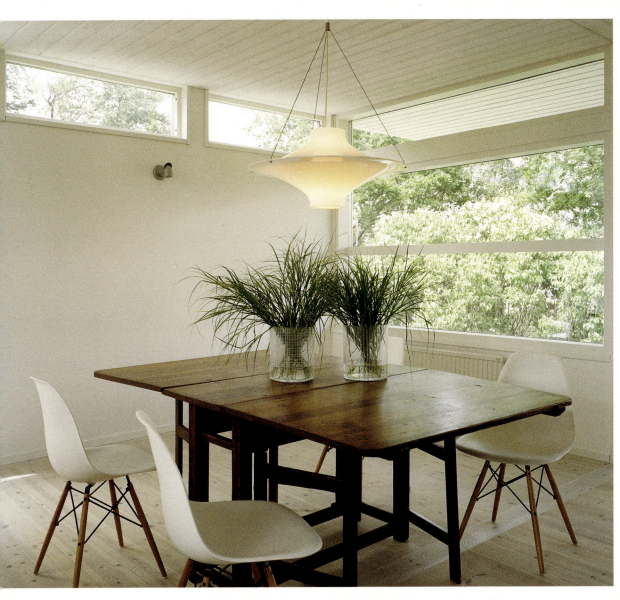

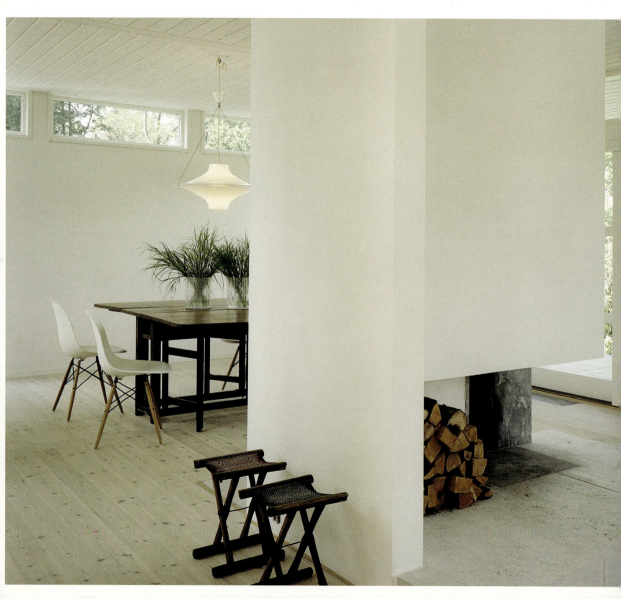

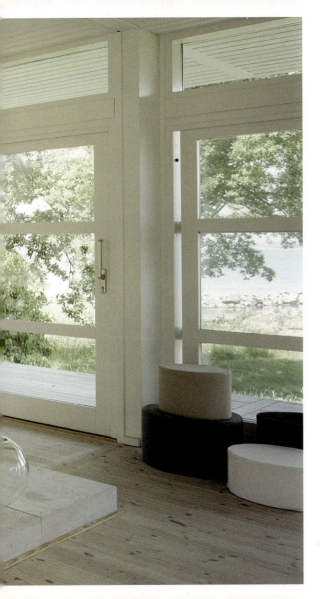

**Giorgio Marè | Turin, Italy**
White Loft
Milan, Italy | 2003

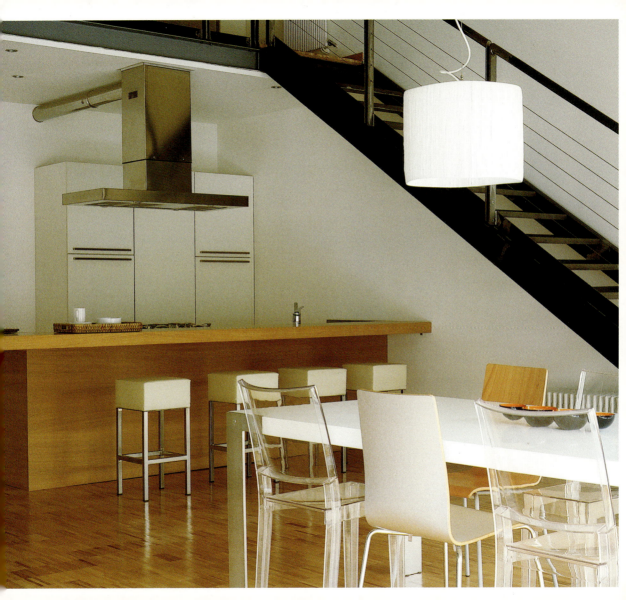

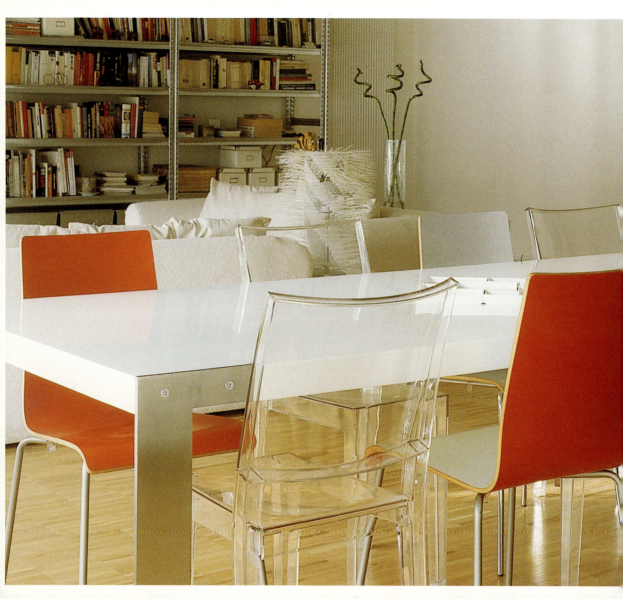

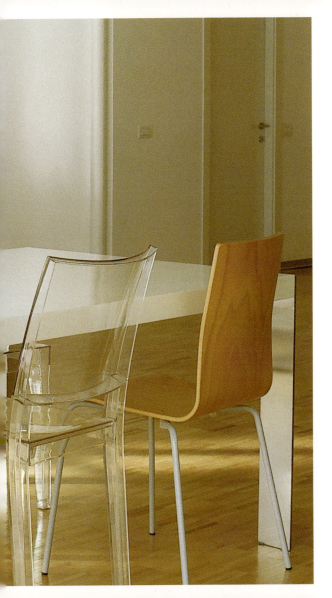

**GMC Interiores | Esplugues de Llobregat, Spain**
Custom-made Residence
Barcelona, Spain | 2004

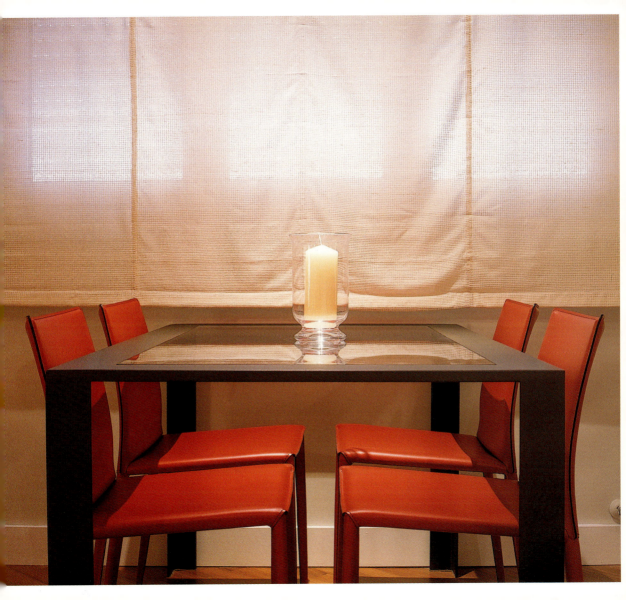

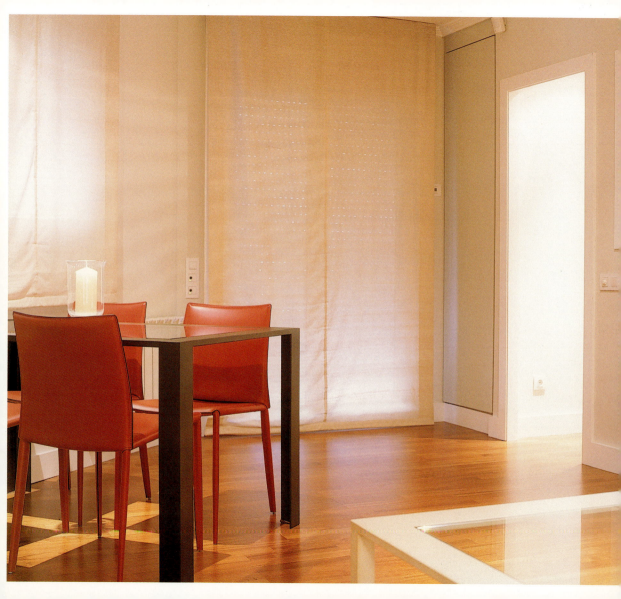

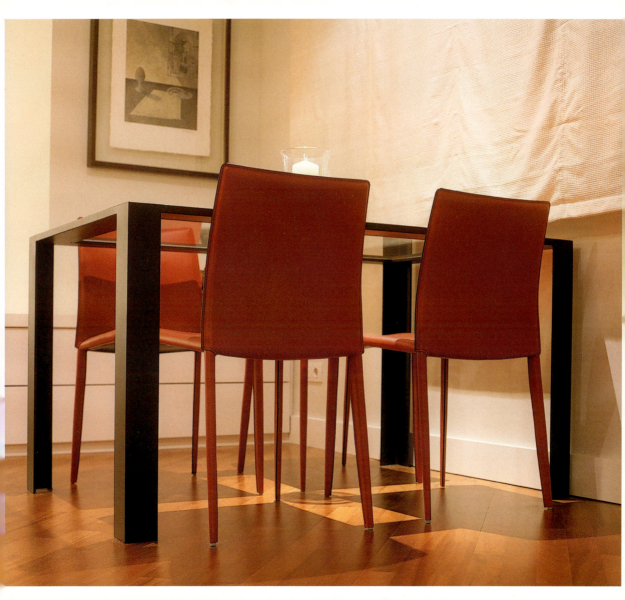

**Graft | Berlin, Germany**
Loft Zeal
Berlin, Germany | 2004

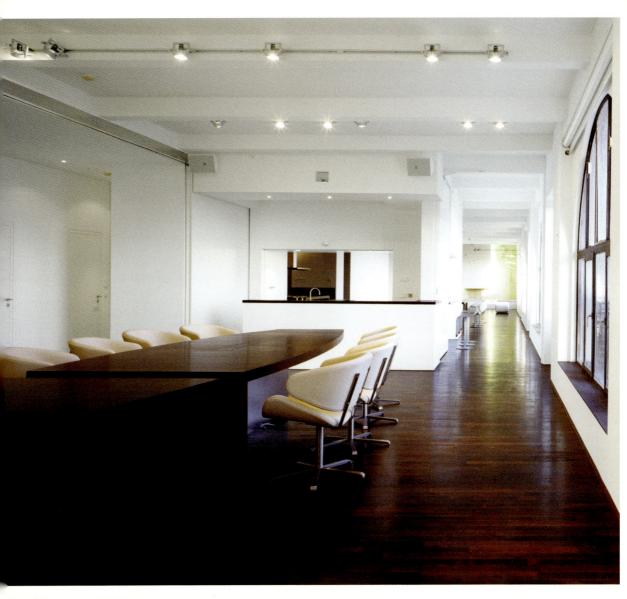

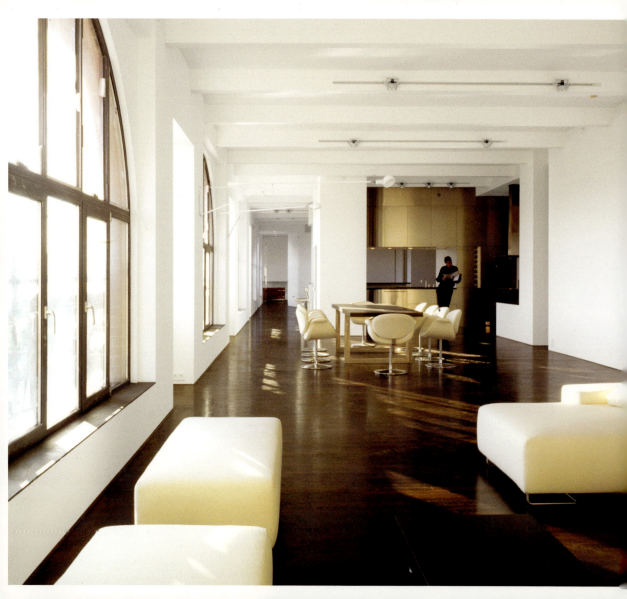

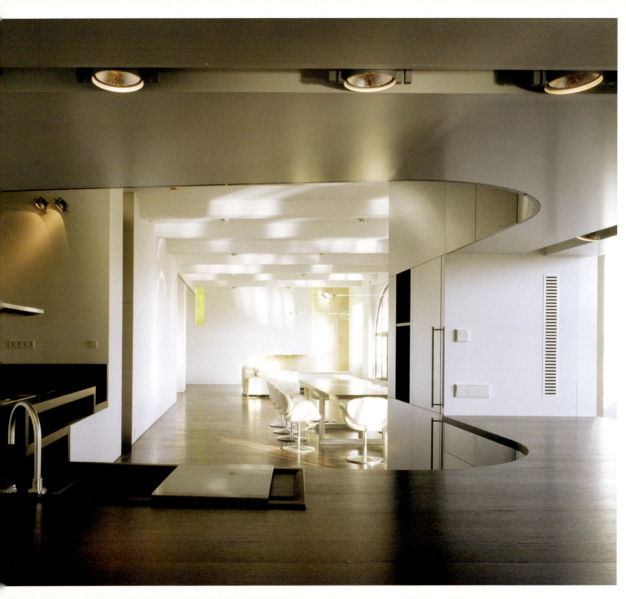

**Greek | Barcelona, Spain**
House in Esplugues
Barcelona, Spain | 2004

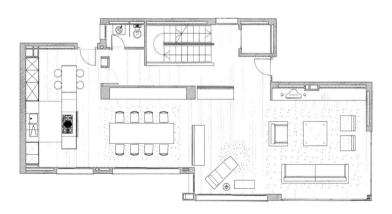

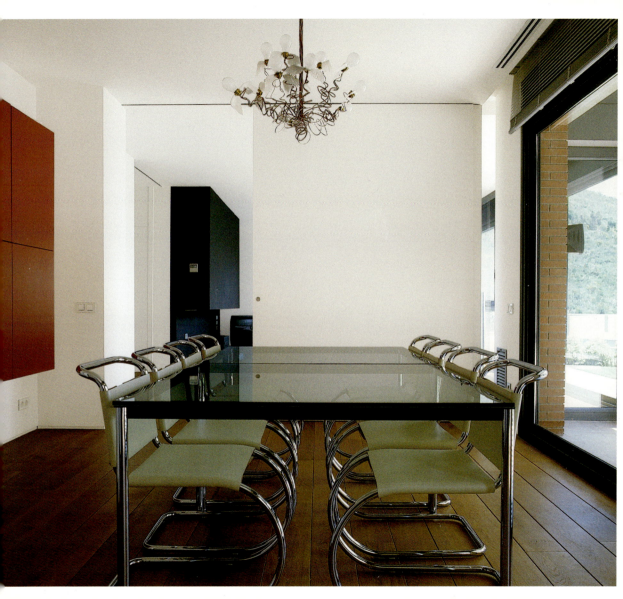

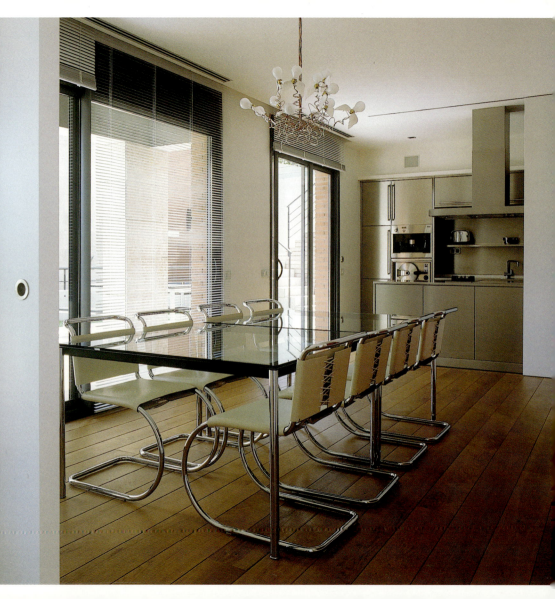

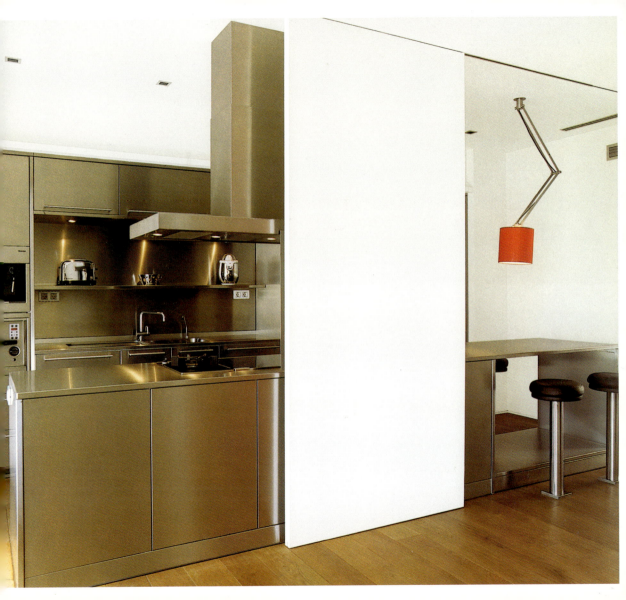

**Gustavo Barba | Barcelona, Spain**
Fusina Street Flat
Barcelona, Spain | 2003

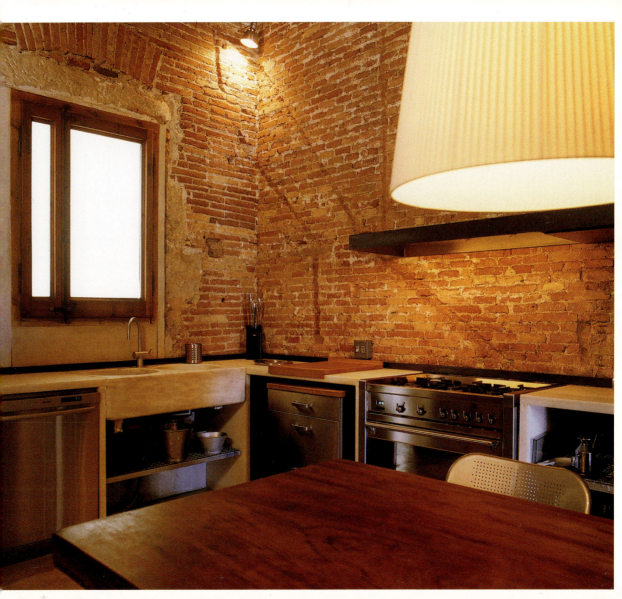

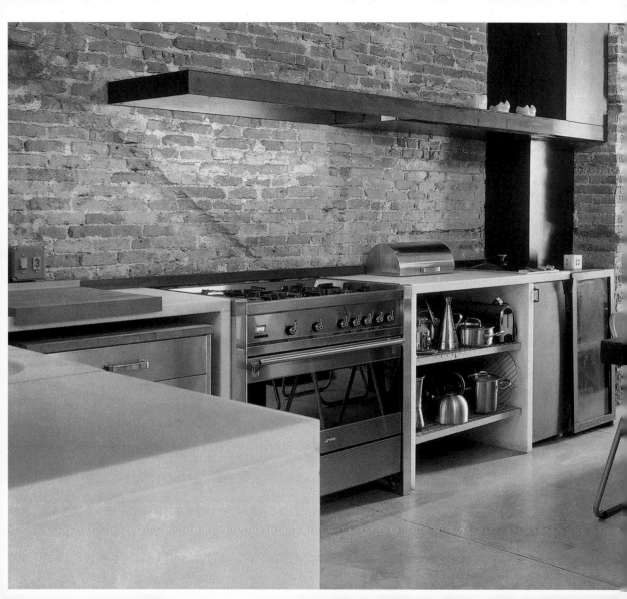

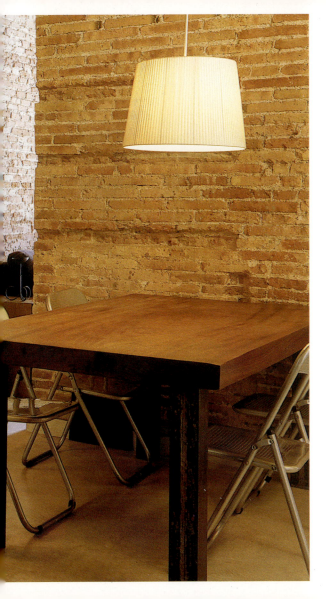

**Jaime Gaztelu | Madrid, Spain**
Gutiérrez Apartment
Madrid, Spain | 2005

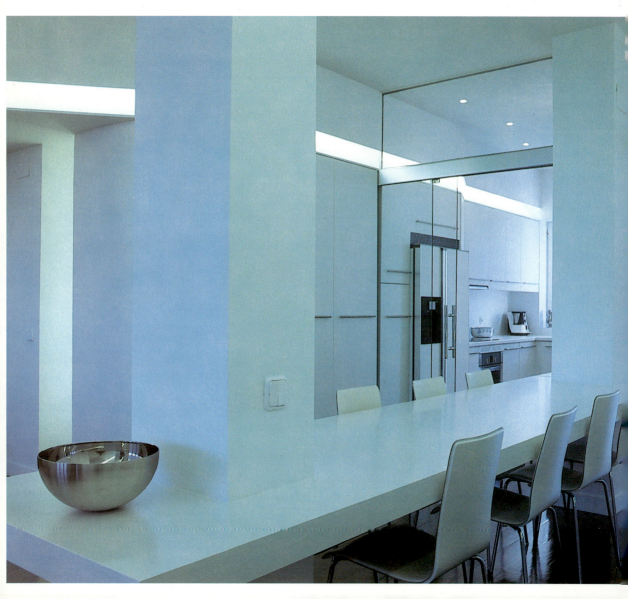

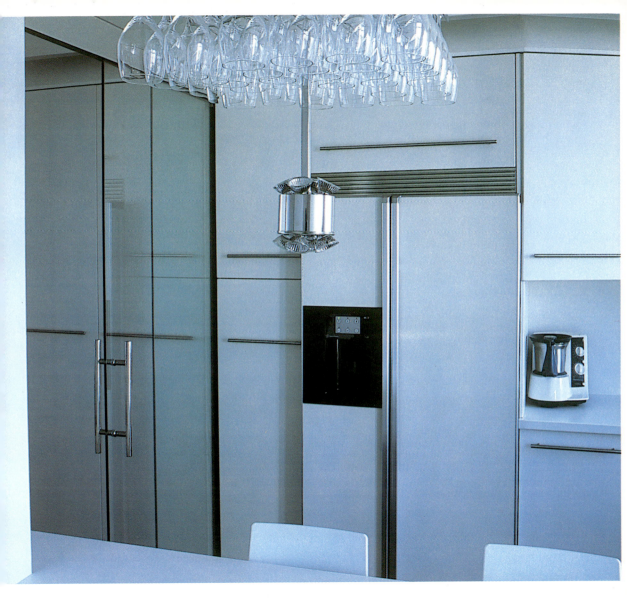

**Joan Bach | Barcelona, Spain**
Fraternitat Duplex
Barcelona, Spain | 2003

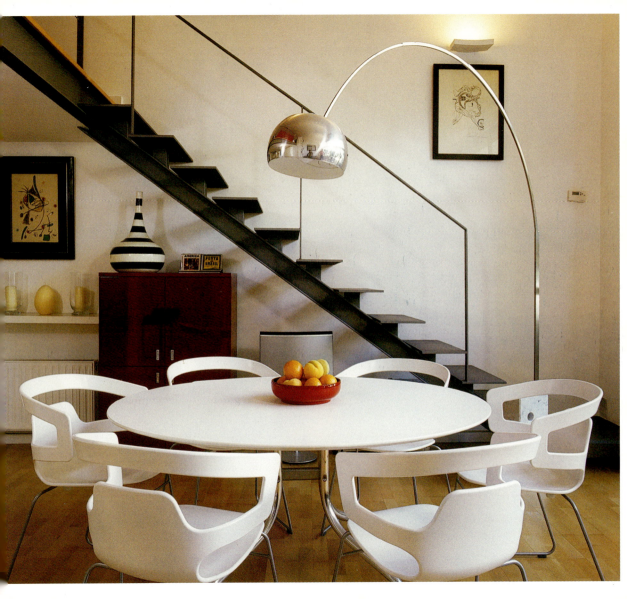

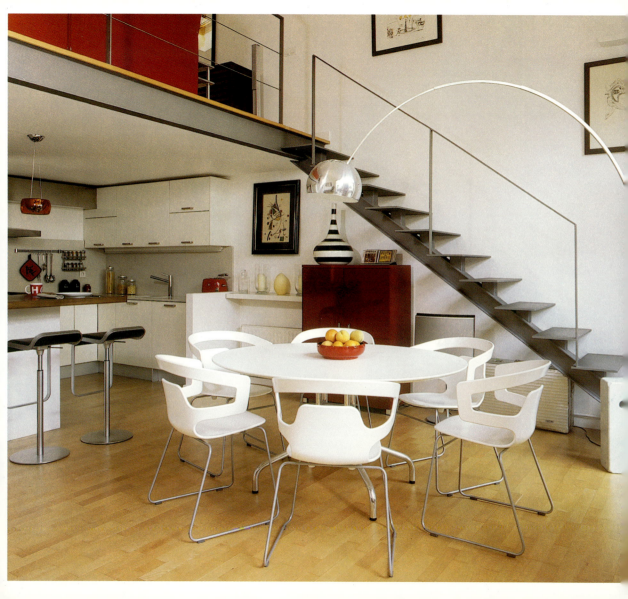

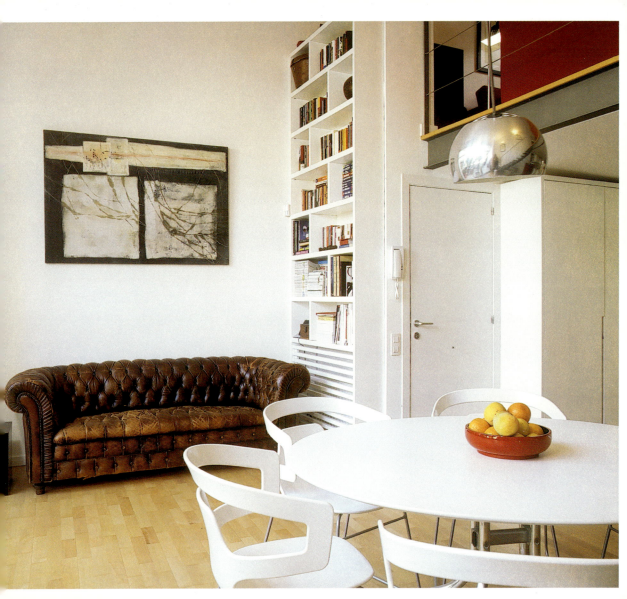

**Lucia Bisi, Elena Lazzeri, Maurizio Monteforte | Milan, Italy**
Caproni Loft
Milan, Italy | 2004

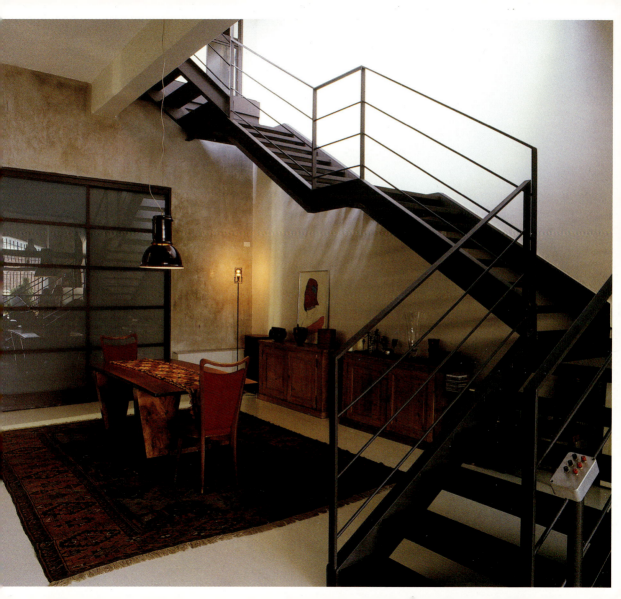

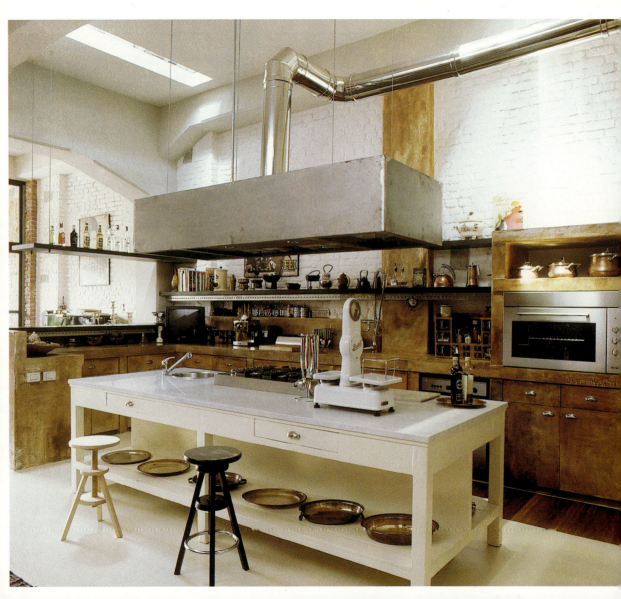

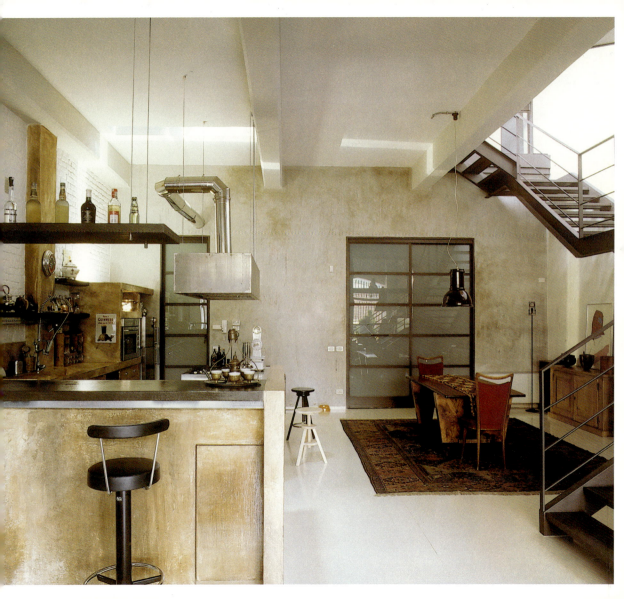

**MAP Arquitectos | Barcelona, Spain**
House in Begur
Begur, Spain | 2004

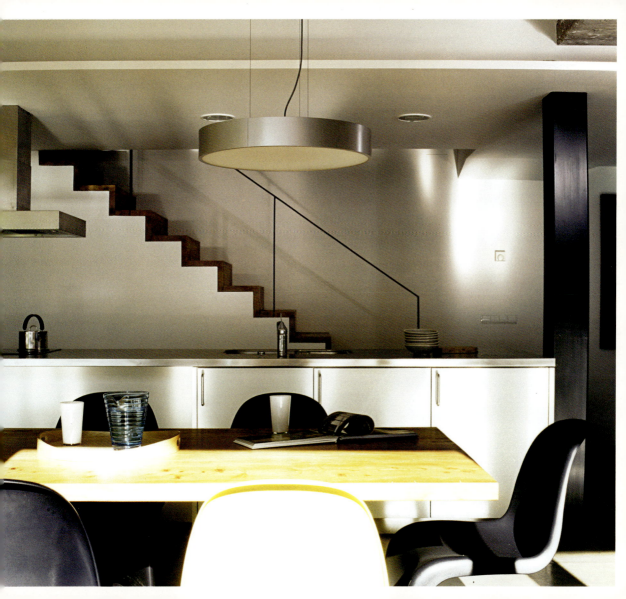

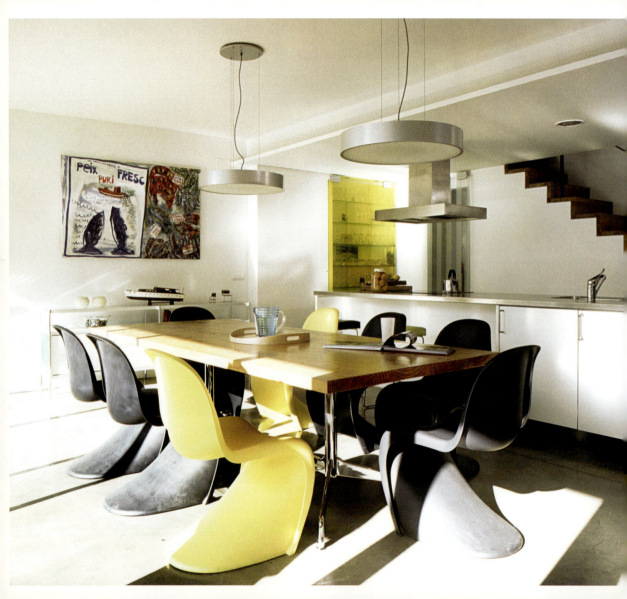

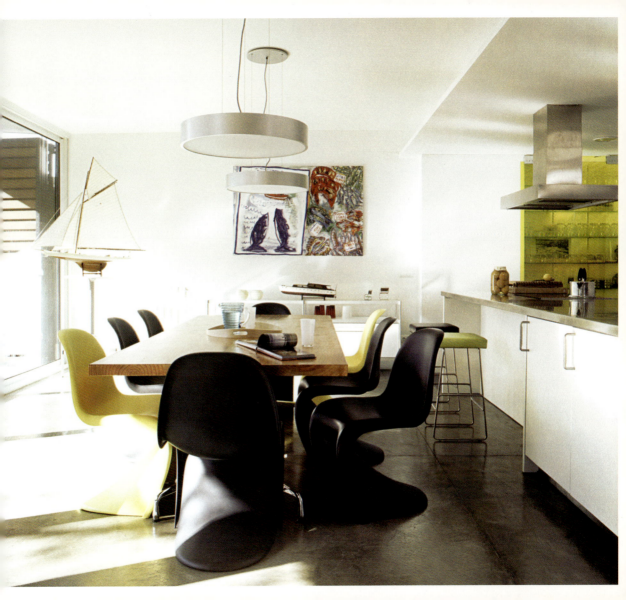

**Mariana Castro, Nacho Martí | Barcelona, Spain**
MC Flat
Barcelona, Spain | 2004

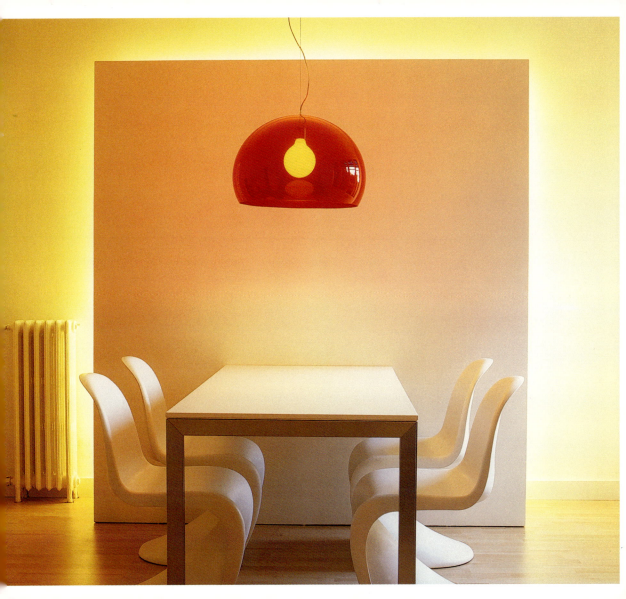

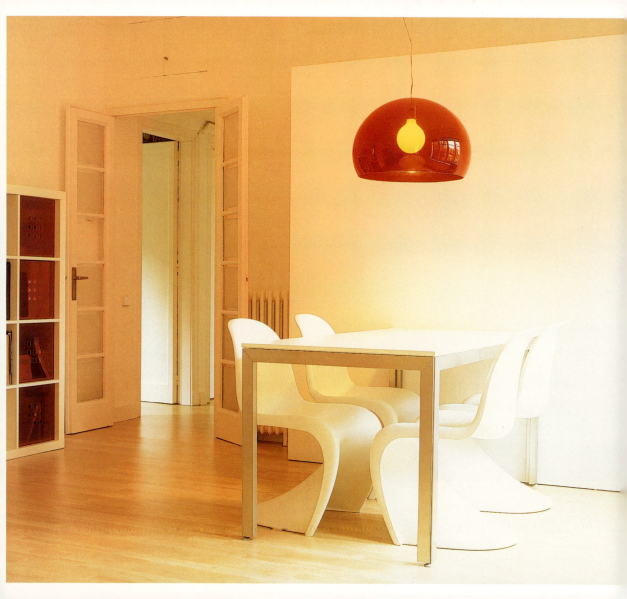

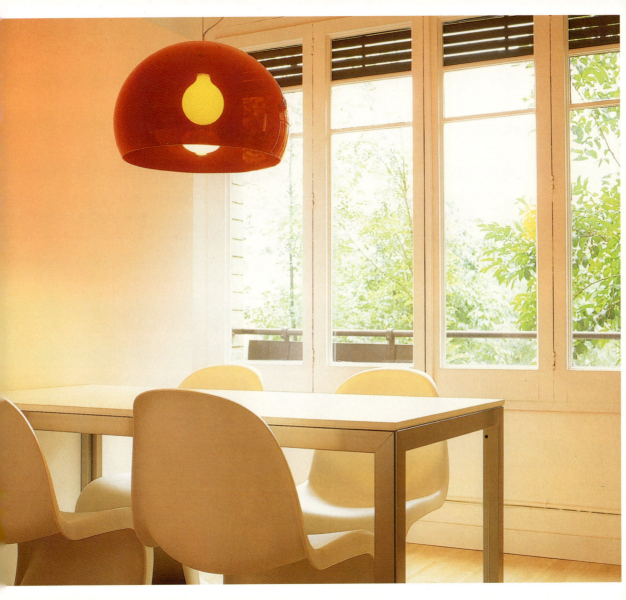

**Massimo Sottili | Milan, Italy**
Archetipo Loft
Milan, Italy | 2004

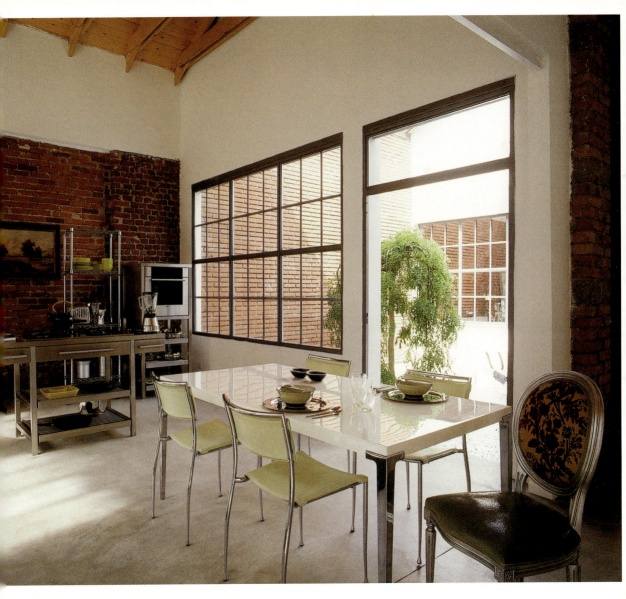

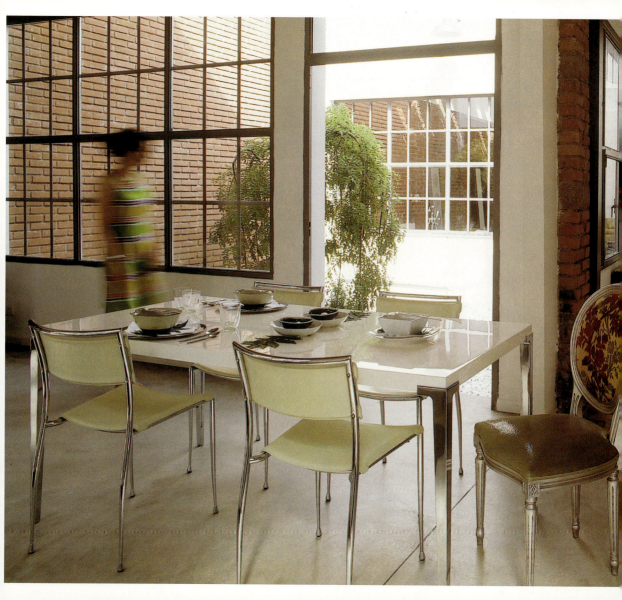

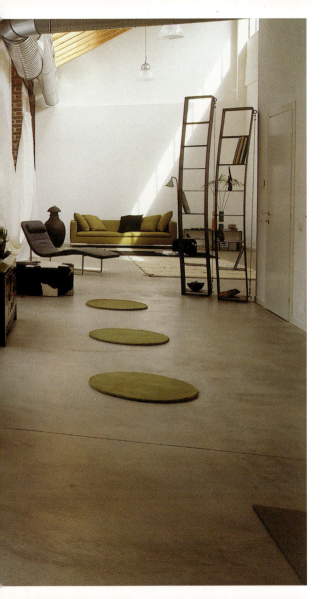

**Maximià Torruella Castel | Barcelona, Spain**
Apartment in Barcelona
Barcelona, Spain | 2002

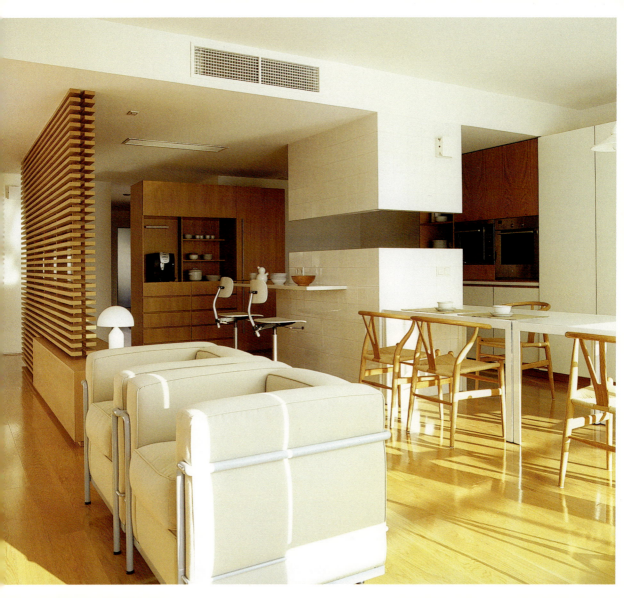

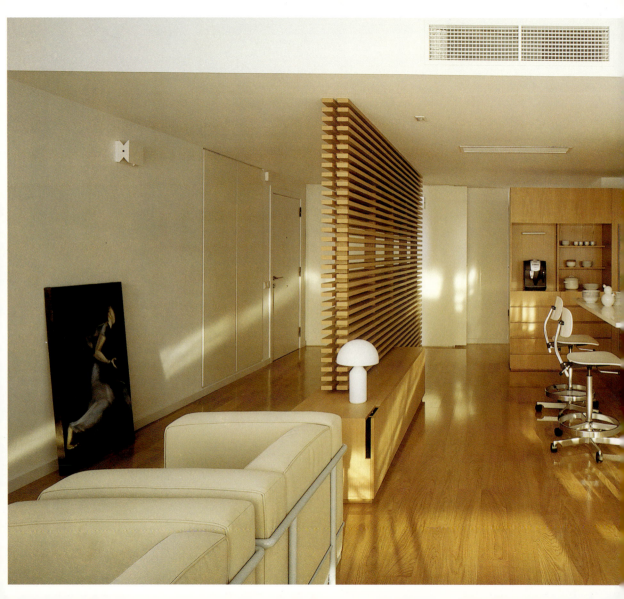

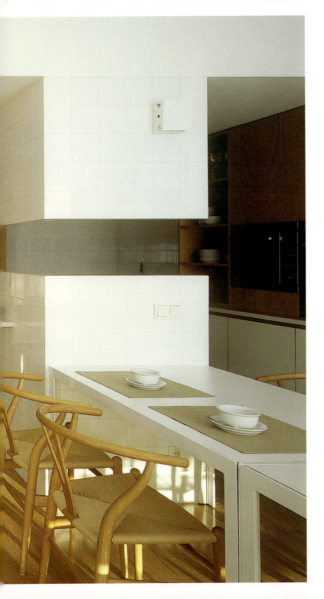

**Minim | Barcelona, Spain**
House in Fatarella
Tarragona, Spain | 2004

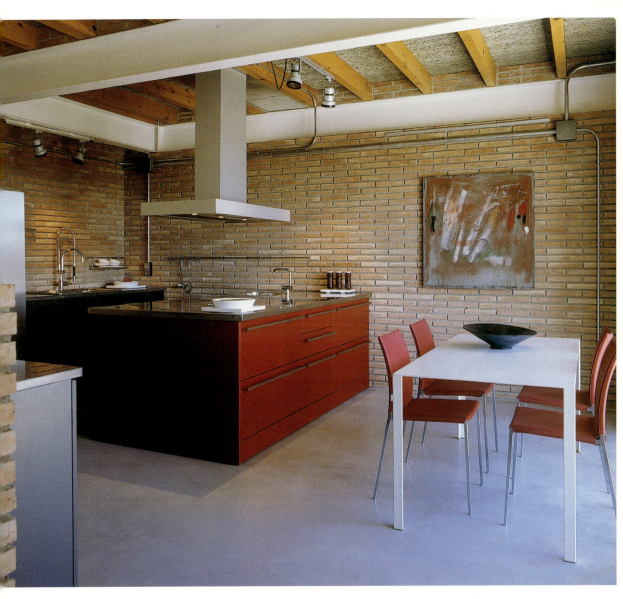

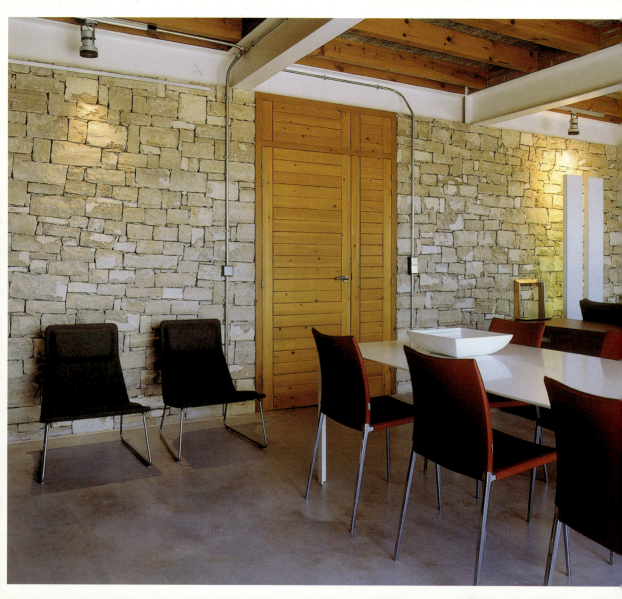

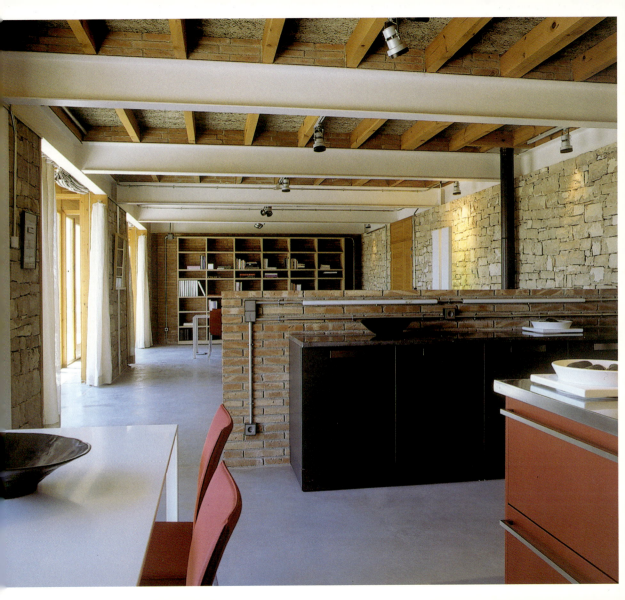

**Moneo Brock Studio | Madrid, Spain**
Hudson Street Loft
New York, USA | 2000

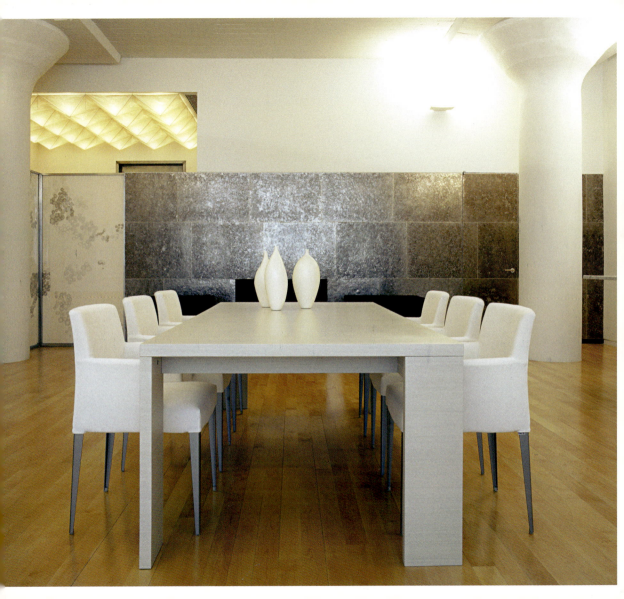

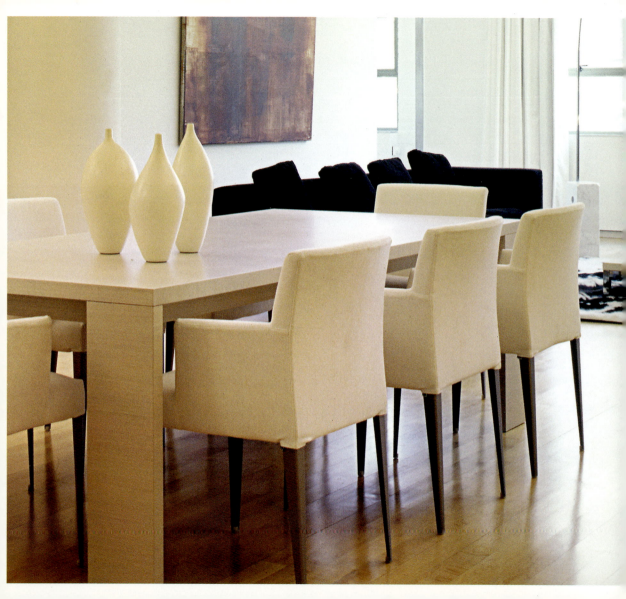

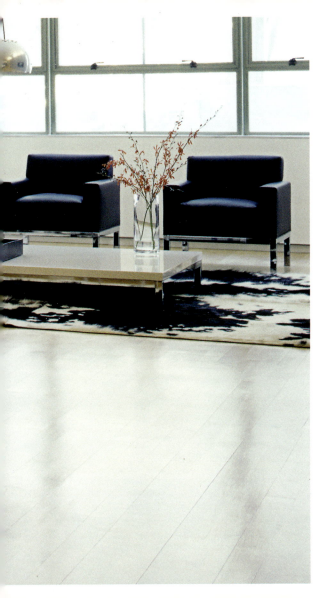

**Moneo Brock Studio | Madrid, Spain**
Greenwich Street Loft
New York, USA | 2000

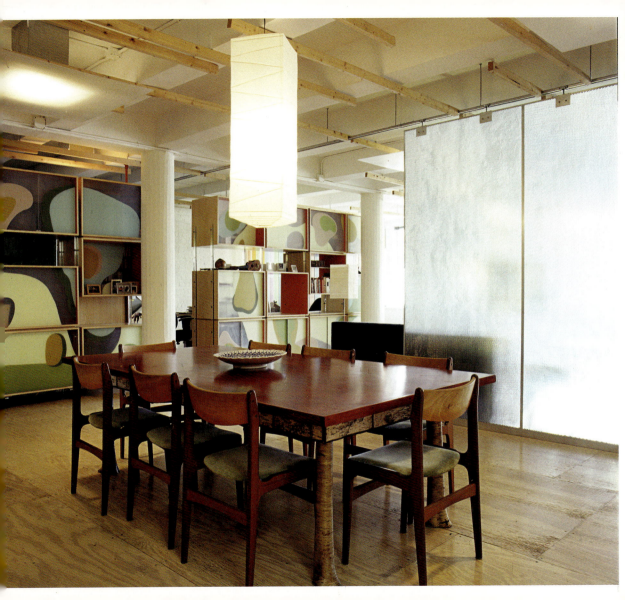

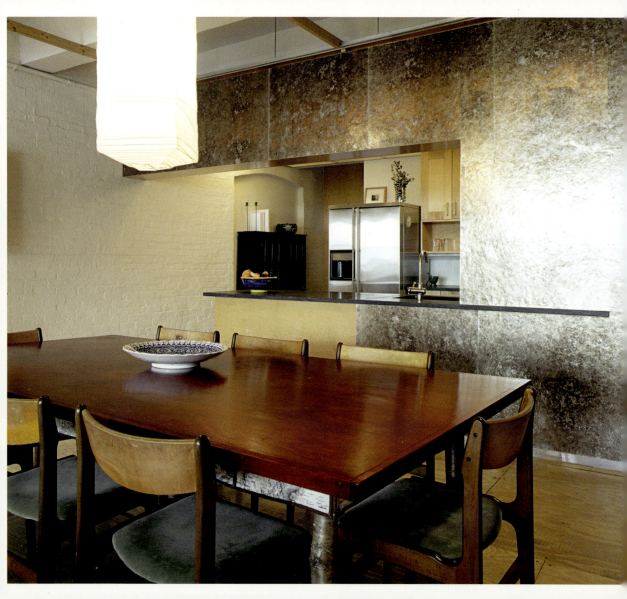

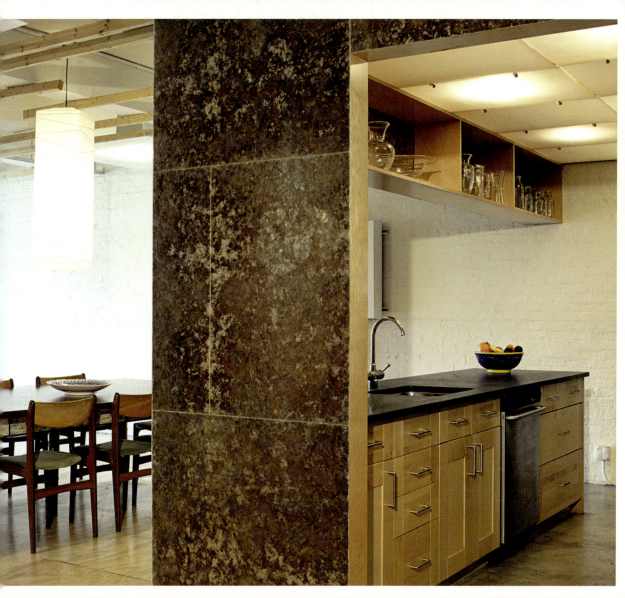

**Nosuch | Stockholm, Sweden**
Apartment in Stockholm
Stockholm, Sweden | 2001

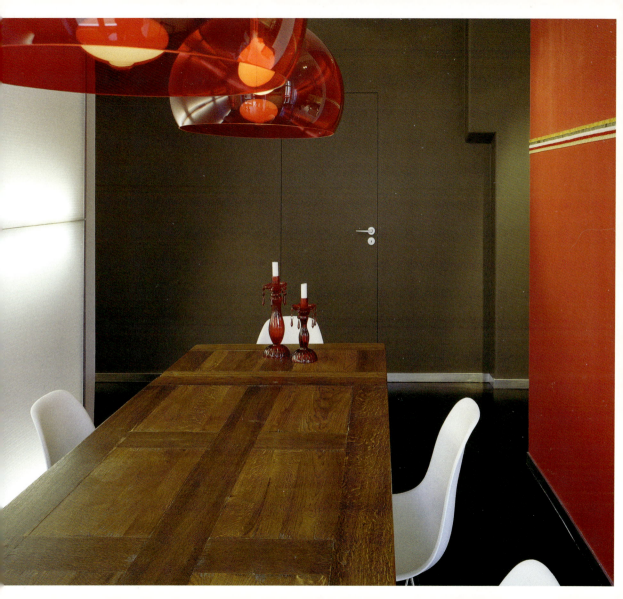

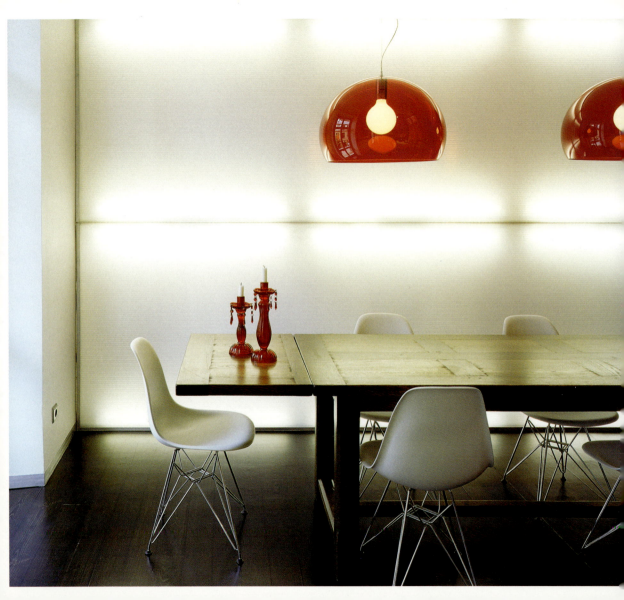

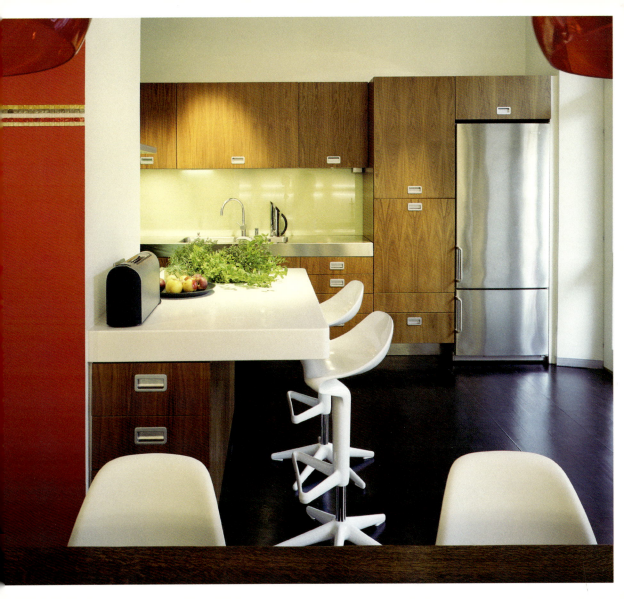

**Oriol Rosselló Viñas | Barcelona, Spain**
Prada House
Sant Vicenç de Montalt, Spain | 2001

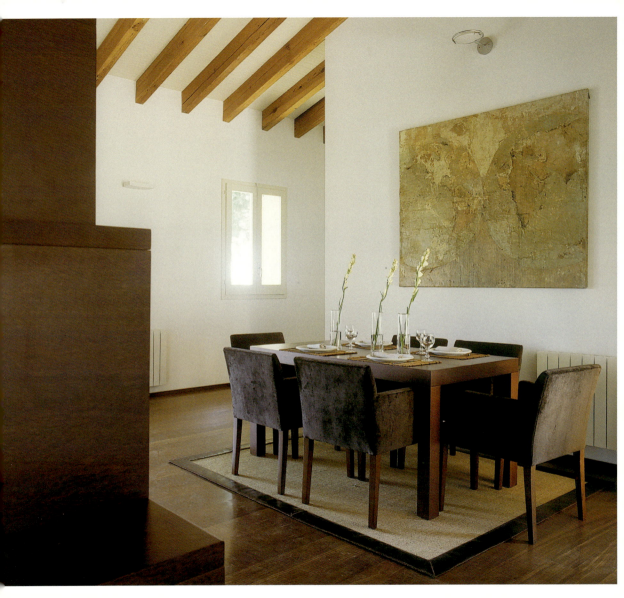

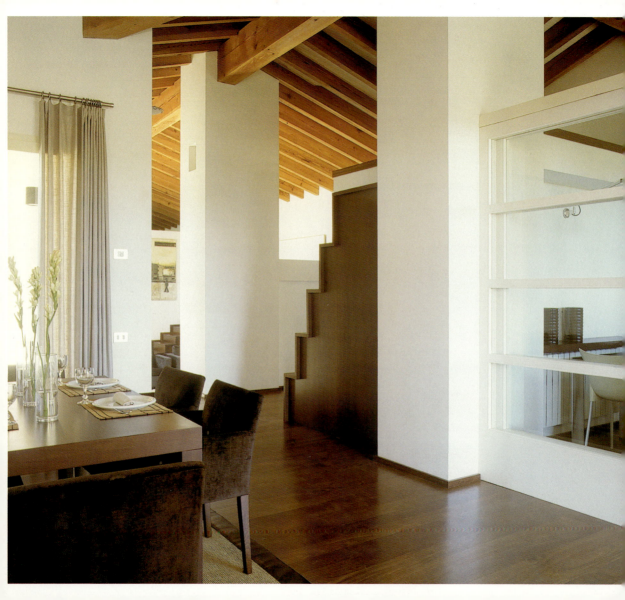

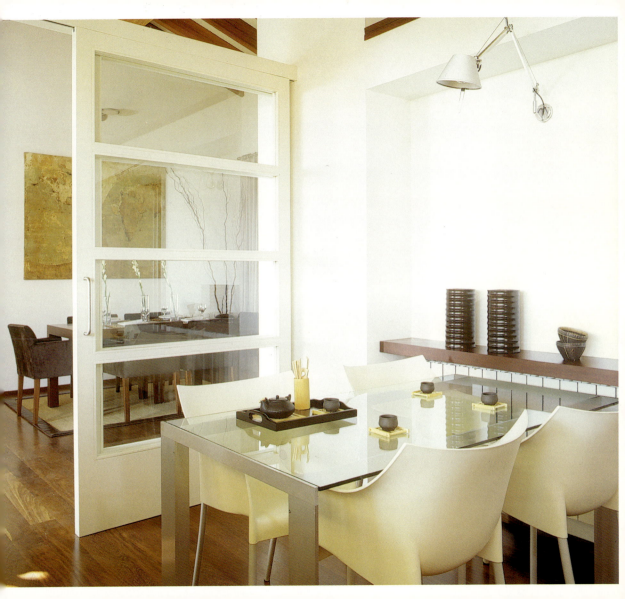

**Ramón Rodríguez | Barcelona, Spain**
Loft Duplex Cortines
Barcelona, Spain | 2001

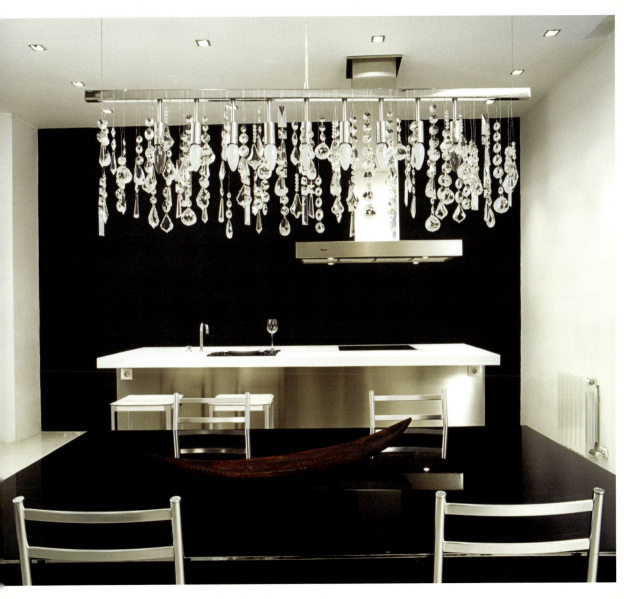

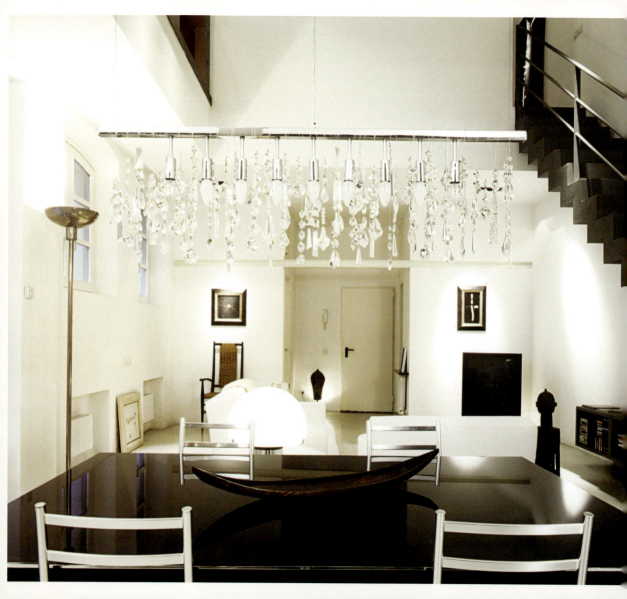

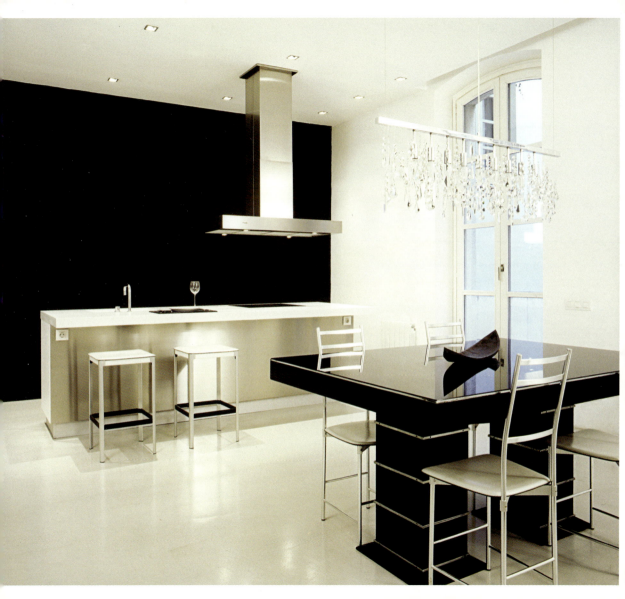

**Redmark & Partners, Marco Michele Rossi | Milan, Italy**
Alessandro Betteni Loft
Milan, Italy | 2000

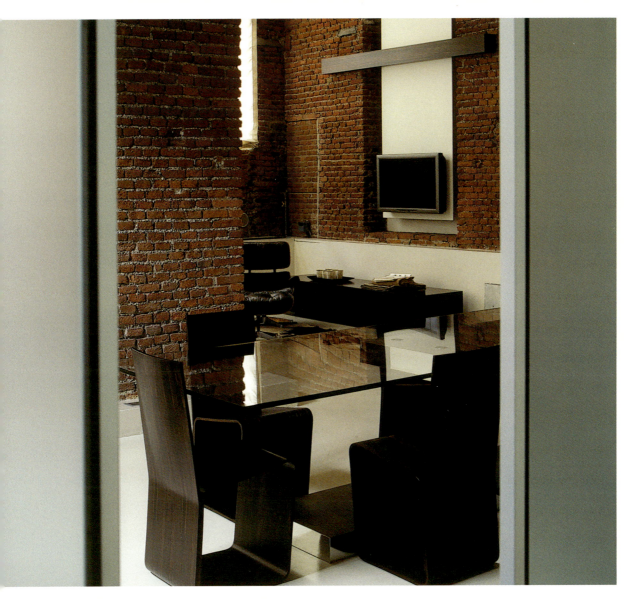

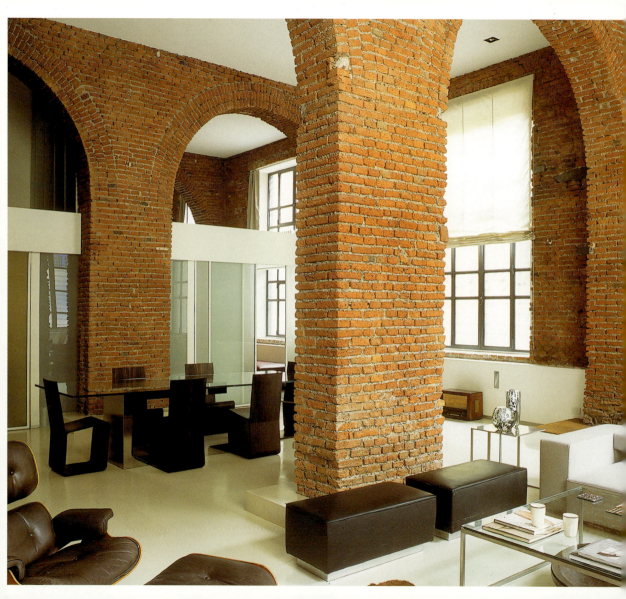

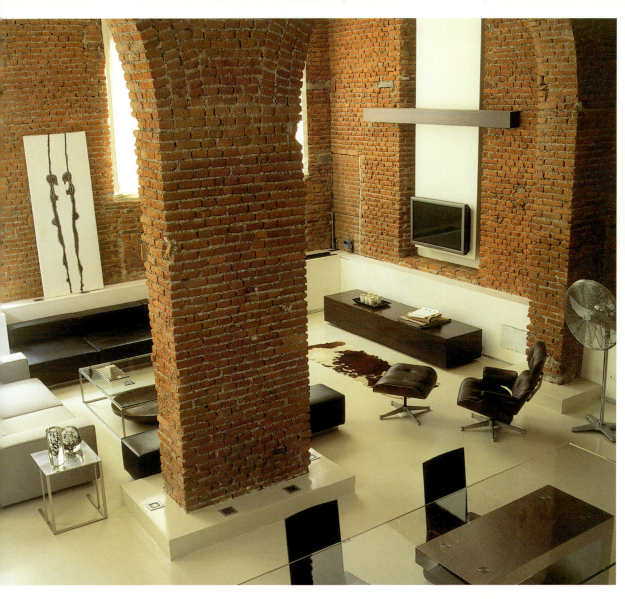

**Sepllobetarquitectes | Barcelona, Spain**
Aida and Jordi's House
Girona, Spain | 2003

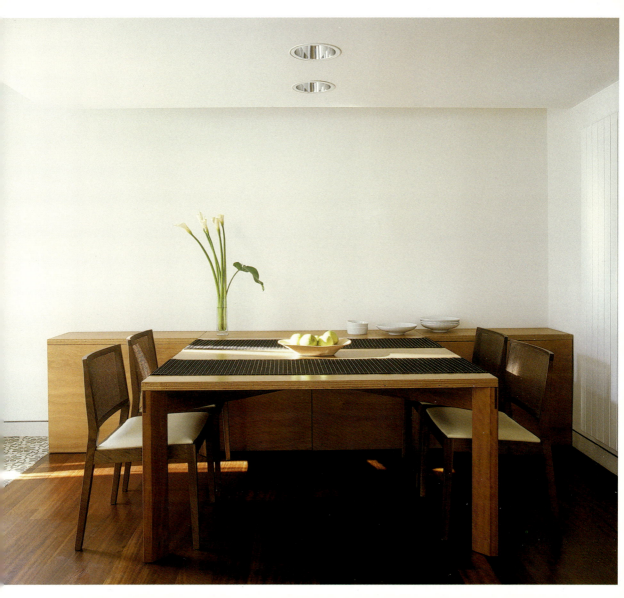

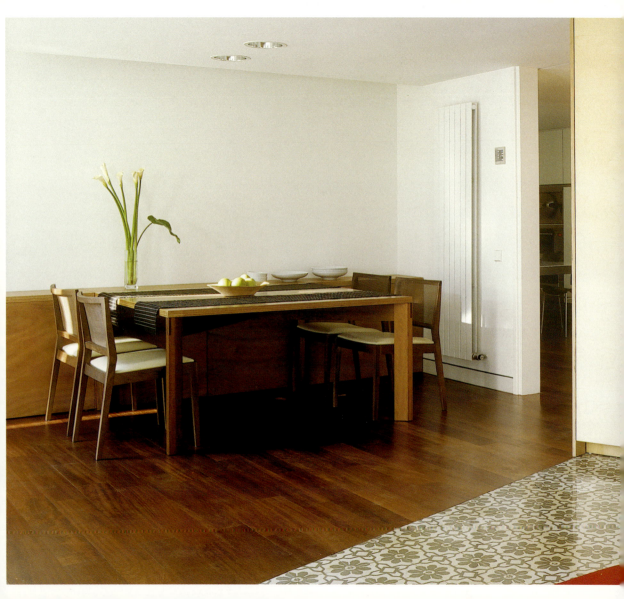

**Silvia Via | Barcelona, Spain**
Loft One
Barcelona, Spain | 2002

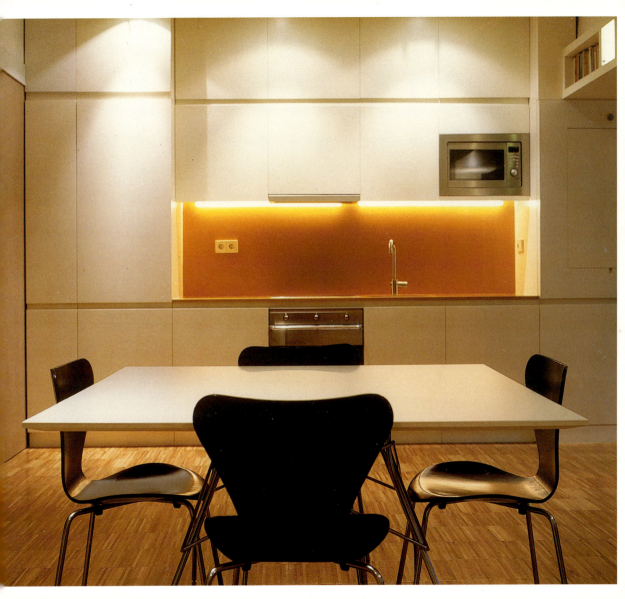

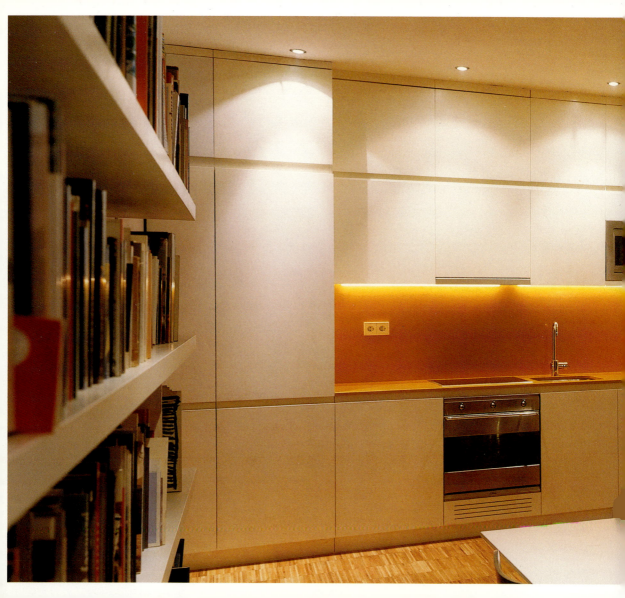

**Simon Conder | London, UK**
Garden Room in North London
London, UK | 2005

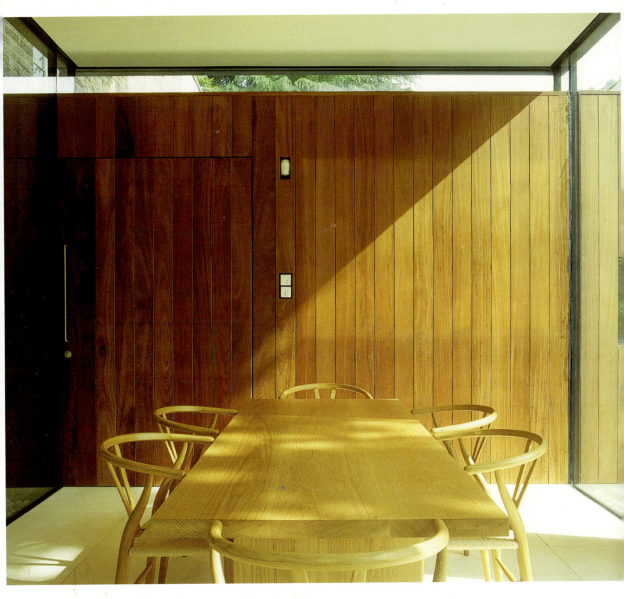

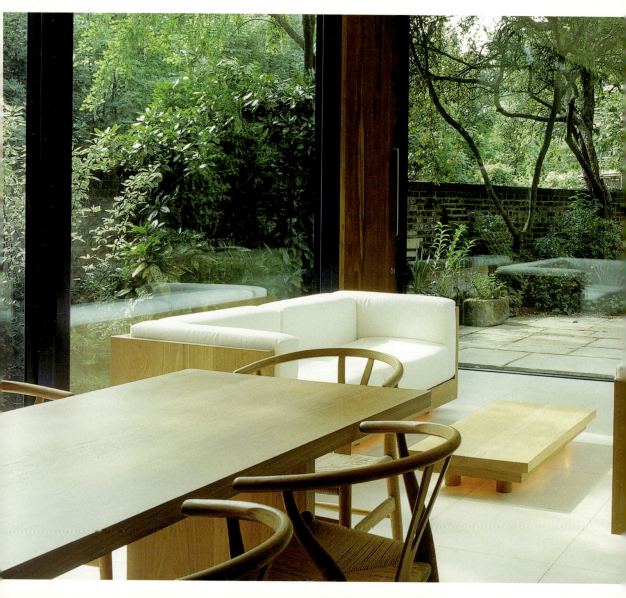

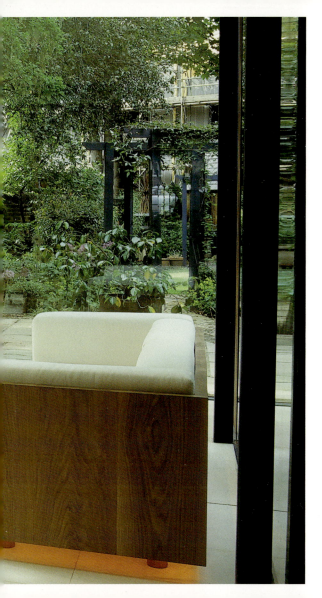

**Studio Architetti Associati | Savignano sul Rubicone, Italy**
House in San Leo
San Leo, Italy | 2004

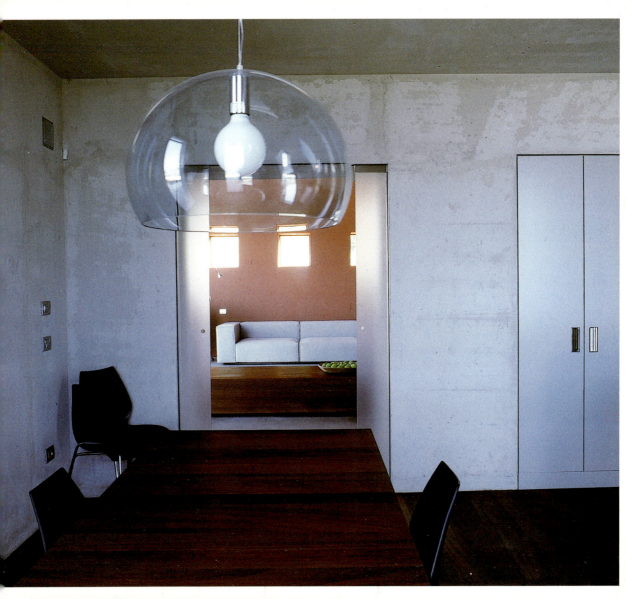

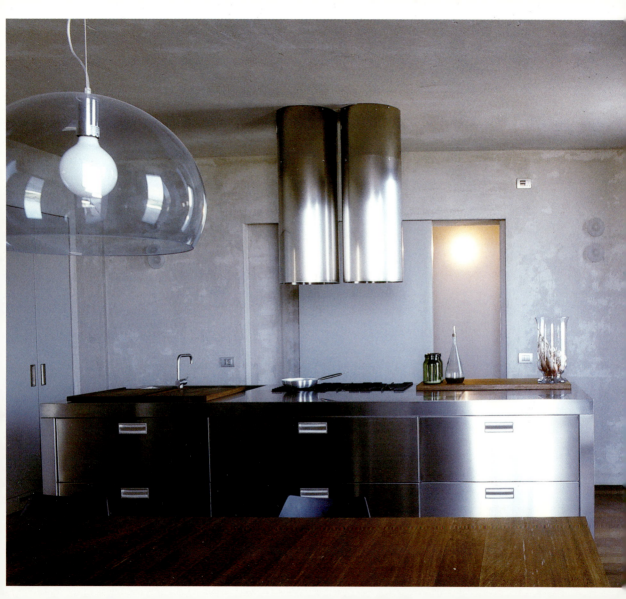

**Studio Associato Falconi | Paderno Franciacorta, Italy**
Bonomi House
Brescia, Italy | 1999

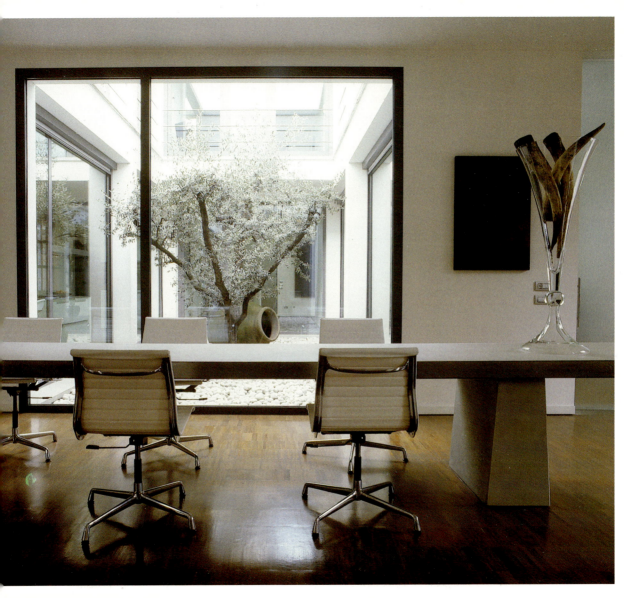

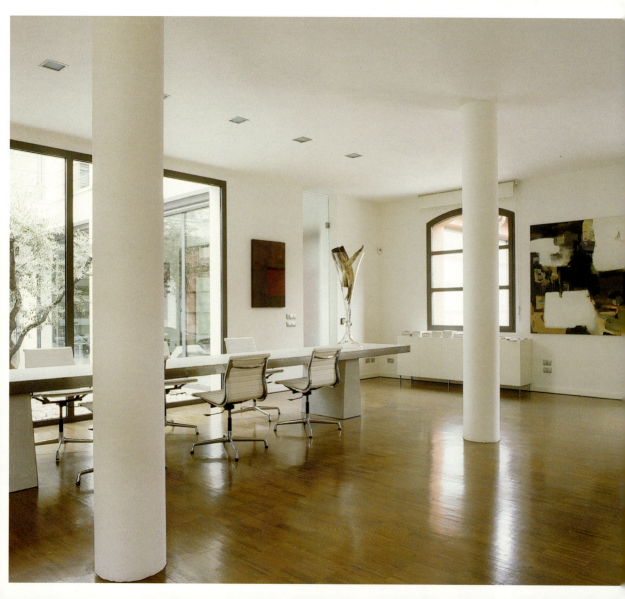

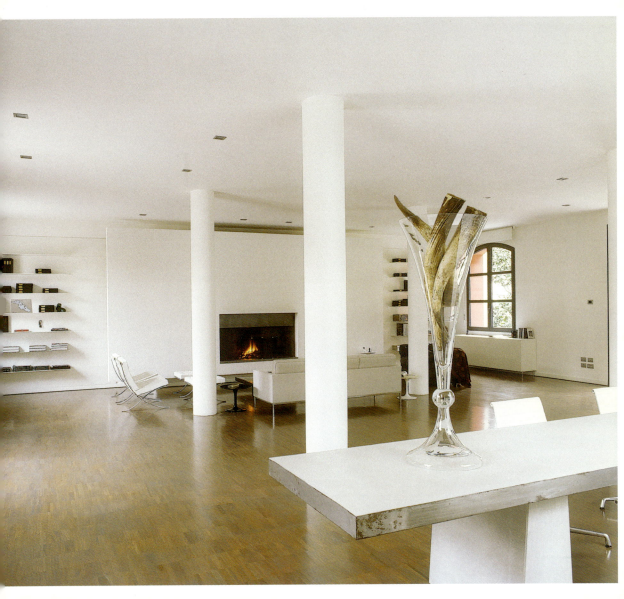

**Studio Job | Antwerp, Belgium**
Studio Job
Antwerp, Belgium | 2003

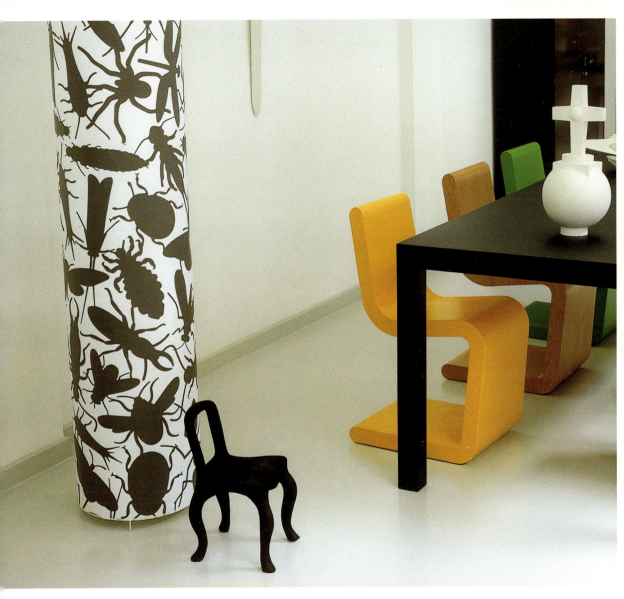

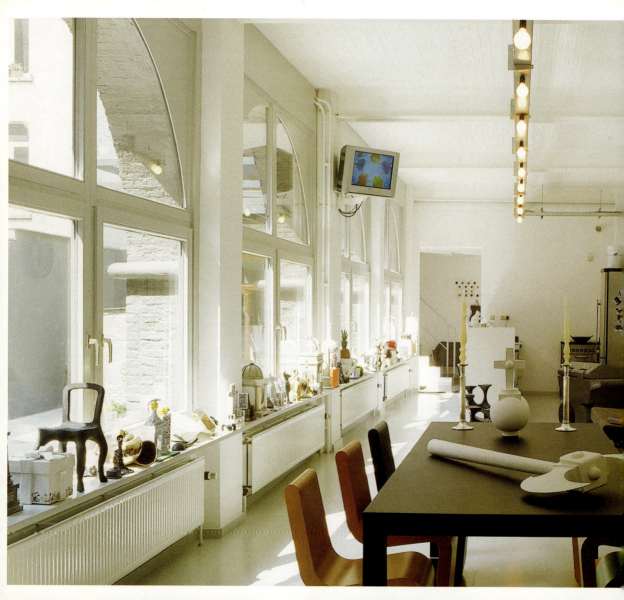

**White Architects White Design | Goteborg, Sweden**
Optibo
Goteborg, Sweden | 2003

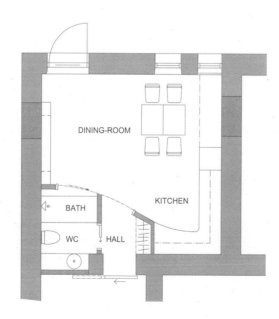

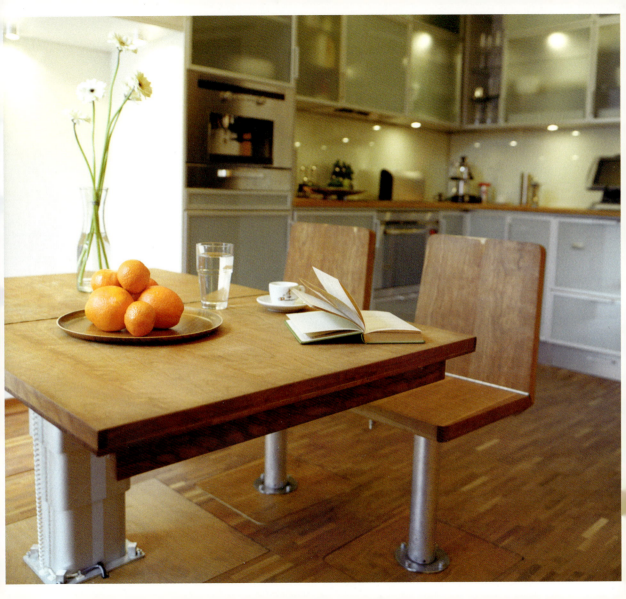

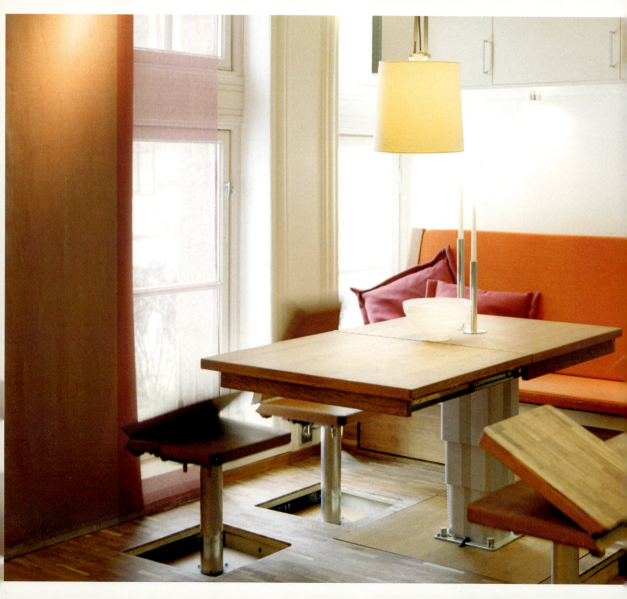

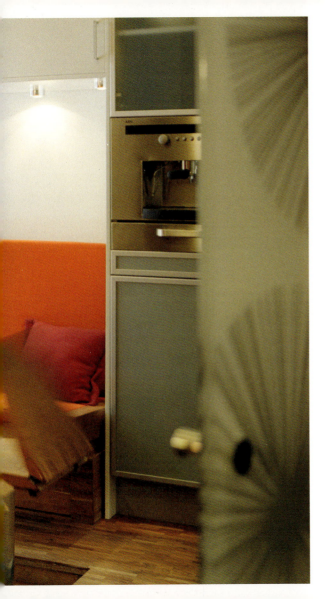

**Air Projects**
Pau Claris 179 3.º 1.ª, 08037 Barcelona, Spain
P +34 932 722 427
F +34 932 722 428
air@air-projects.com
www.air-projects.com
Apartment Reina Victoria, House in Girona, Loft Vapor Llull
Photos: © Jordi Miralles

**Alberto Martínez Carabajal**
Escuelas Pías 40 bajos, 08017 Barcelona, Spain
P +34 934 182 508
F +34 934 182 507
martinez.carabajal@coac.net
House Girona
Photos: © Jordi Miralles

**Alfons Soldevila Barbosa**
Castanyers 11, 08916 Badalona, Spain
P +34 933 952 854
F +34 933 952 854
soldevila@coac.net
Tiana-Alella House
Photos: © Jordi Miralles

**Ars Spatium Space Design**
Espinoi 12 bajos, 08023 Barcelona, Spain
P +34 934 343 470
F +34 934 182 386
ars@arsspatium.com
www.arsspatium.com
Apartment Collserola
Photos: © Jordi Miralles

**AV62 Arquitectos**
Girona 62 bajos dcha., 08009 Barcelona, Spain
P +34 932 312 266
F +34 932 313 734
info@av62arquitectos.com
www.av62arquitectos.com
Apartment Bruc, Two Houses in Plentzia
Photos: © Eugeni Pons

**BMMC Architects & Engineers**
Piazza Borromeo 10, 20123 Milan, Italy
P +39 02 805 54 87
F +39 02 802 99 023
claudia.montevecchi@bmmc.it
www.bmmc.it
Carlo and Lella's House
Photos: © Giulio Oriani / Vega MG

**Cho Slade Architecture**
367 East 10th Street, New York, NY 10009, USA
P +01 212 677 6380
F +01 212 677 6330
james@sladearch.com
www.sladearch.com
Smith Loft, Noho Loft
Photos: © Jordi Miralles

**Claesson Koivisto Rune**
Sankt Paulsgatan 25, SE-118 48 Stockholm, Sweden
P +46 8 644 58 63
F +46 8 644 58 83
arkitektkontor@claesson-koivisto-rune.se
www.claesson-koivisto-rune.se
Kjell Nordströms Residence
Photos: © Åke E:son Lindman

**Claudi Aguiló Riu, Xavier Vendrell Sala**
Av. Icària 180 6.º 1.ª, 08005 Barcelona, Spain
P +34 932 655 486
F +34 932 466 829
car@bailen28.net
Tamarit-Vendrell House
Photos: © Jordi Miralles

**Co Twee**
Cuylitsstraat 14, 2018 Antwerp, Belgium
P +32 3 289 43 49
F +32 3 237 68 79
co@pandora.be
Sullo Shelde House
Photos: © Giorgio Possenti / Vega MG

**David Luck Architecture**
17 Hardy Street, 3141 South Yarra, Australia
P +61 3 9867 7509
david.luck@bigpond.com
www.users.bigpond.com/david.luck
Douralis House
Photos: © Shania Shegedyn

**David Maturen, Arantxa Garmendia**
Santa Isabel 3 ático, 50003 Zaragoza, Spain
P +34 976 392 407
F +34 976 399 895
davidmaturen@hotmail.com
Penthouse
Photos: © Jordi Miralles

**Emanuele Tettamanzi**
Apartment in Cantù
Photos: © Linda Vismara/Vega MG

**Eriksson Thomas Arkitekter**
Riddargatan 17d, 114 57 Stockholm, Sweden
P +46 8 555 518 00
F +46 8 555 518 99
mail@teark.se
www.teark.se
House in Karlskrona
Photos: © Åke E:son Lindman

**Giorgio Marè**
Via Paolini 24, 10138 Turin, Italy
P +39 011 43 31 729
F +39 011 43 31 729
giorgio.mare@infinito.it
White Loft
Photos: © Giulio Oriani/Vega MG

**GMC Interiores**
Emili Juncadella 1-3 2.º 2.ª esc C, 08950 Esplugues de Llobregat, Spain
P +34 639 656 233
F +34 933 712 992
gmcinteriores@telefonica.net
Custom-made Residence
Photos: © Gogortza & Llorella

**Graft**
Borsigstrasse 33, 10115 Berlin, Germany
P +49 30 2404 7985
F +49 30 2404 7987
berlin@graftlab.com
www.graftlab.com
Loft Zeal
Photos: © Graft

**Greek**
Rubinstein 4, 08022 Barcelona, Spain
P +34 934 189 550
F +34 934 189 532
greek@greekbcn.com
www.greekbcn.com
House in Esplugues
Photos: © Núria Fuentes

**Gustavo Barba**
Antic de Sant Joan 12 2.ª, 08003 Barcelona, Spain
P +34 932 682 103
arteks@andorra.ad
Fusina Street Flat
Photos: © Núria Fuentes

**Jaime Gaztelu**
García de Paredes 11 1-15, 28010 Madrid, Spain
P +34 914 470 724
jaime.gaztelu@gmail.com
Gutiérrez Apartment
Photos: © Antonio Corchera

**Joan Bach**
Passeig de Gràcia 52 pral., 08007 Barcelona, Spain
P +34 934 881 925
F +34 934 871 670
joan.bach@coac.net
Fraternitat Duplex
Photos: © Jordi Miralles

**Lucia Bisi, Elena Lazzeri, Maurizio Monteforte**
Piazza Risorgimento 6, 20129 Milan, Italy
P +39 02 76 01 80 71
F +39 02 76 31 06 24
m.mont@tiscali.it
Loft Caproni
Photos: © Gianni Basso/Vega MG

**MAP Arquitectos**
Passeig de Gràcia 108 6.º, 08008 Barcelona, Spain
P +34 932 186 358
F +34 932 185 292
map@mateo-maparchitect.com
www.mateo-maparchitect.com
House in Begur
Photos: © Jordi Miralles

**Mariana Castro, Nacho Martí**
Av. República Argentina 159 1.º 2.ª, 08023 Barcelona, Spain
P +34 932 118 354
F +34 932 118 354
info@nachomarti.com
www.nachomarti.com
MC Flat
Photos: © Gogortza & Llorella

**Massimo Sottili**
Via Mecenate 84, 20138 Milan, Italy
P +39 02 58 01 35 48
F +39 02 58 01 35 48
massimosottili@libero.it
Loft Archetipo
Photos: © Gianni Basso/Vega MG

**Maximià Torruella Castel**
Av. Sarrià 137-139 int. bjos., 08017 Barcelona, Spain
P +34 932 055 376
F +34 932 058 040
maximia-torruella@coac.net
www.arquitecturagb8.com
Apartment in Barcelona
Photos: © Eugeni Pons

**Minim**
Av. Diagonal 369, 08037 Barcelona, Spain
P +34 932 722 425
F +34 934 883 447
info@minim.es
www.minim.es
House in Fatarella
Photos: © Núria Fuentes

**Moneo Brock Studio**
Francisco de Asís Méndez Casariego 7 bjos., 28002 Madrid, Spain
P +34 915 638 056
F +34 915 638 573
contact@moneobrock.com
www.moneobrock.com
Greenwich Street Loft, Hudson Street Loft
Photos: © Jordi Miralles

**Nosuch**
Kocksgatan 25, 116 24 Stockholm, Sweden
P +46 8 644 4810
F +46 8 642 9259
arkitekter@nosuch.se
www.nosuch.se
Apartment in Stockholm
Photos: © Åke E:son Lindman

**Oriol Rosselló Viñas**
Consell de Cent 320, 08007 Barcelona, Spain
P +34 934 872 527
F +34 934 873 651
loriol@coac.net
Prada House
Photos: © Jordi Miralles

**Ramón Rodríguez**
P +34 933 199 507
F +34 933 199 507
monbar67@hotmail.com
Loft Duplex Cortines
Photos: © Jordi Miralles

**Redmark & Partners**
Via Menotti 7, 20129 Milan, Italy
P +39 333 28 13 263
F +39 02 45 48 76 69
redmarkmilano@mybox.it
www.creainternational.com
Loft Alessandro Betteni
Photos: © Denise Bonenti / Vega MG

**Sepllobetarquitectes**
Polònia 20 bjos., 08024 Barcelona, Spain
P +34 932 856 556
F +34 932 841 460
dakasep@coac.net
Aida and Jordi's House
Photos: © Eugeni Pons

**Silvia Via**
Plaza Navas 12 ent. 1.ª, 08004 Barcelona, Spain
P +34 934 261 464
neutra@telefonica.net
Loft One
Photos: © Gogortza & Llorella

**Simon Conder**
8 Nile Street, London N1 7RF, UK
P +44 20 7251 2144
F +44 20 7251 2145
sca@simonconder.co.uk
www.simonconder.co.uk
Garden Room in North London
Photos: © Jordi Miralles

**Studio Architetti Associati**
Corso Vendemini 34, 47039 Savignano sul Rubicone, Italy
P +39 541 941 680
F +39 541 941 680
posta@saa.191.it
House in San Leo
Photos: © Gianni Basso / Vega MG

**Studio Associato Falconi**
Via Oldofredi 21, 25050 Paderno Franciacorta, Italy
P +39 030 657230
F +39 030 6857856
falcu@bresciaonline.it
Bonomi House
Photos: © Gianni Basso / Vega MG

**Studio Job**
Stijfselstraat 10, 2000 Antwerp, Belgium
P +32 323 22 515
F +32 323 25 315
office@studiojob.nl
www.studiojob.be
Studio Job
Photos: © Giorgio Possenti / Vega MG

**White Architects White Design**
Magasinsgatan 10 Box 2502, 403 17 Goteborg, Sweden
P +46 31 60 86 00
F +46 31 60 86 10
info@white.se
www.white.se
Optibo
Photos: © Richard Lindor

© 2005 daab
cologne london new york

published and distributed worldwide by
daab gmbh
friesenstr. 50
d-50670 köln

p +49-221-9410740
f +49-221-9410741

mail@daab-online.de
www.daab-online.de

publisher ralf daab
rdaab@daab-online.de

art director feyyaz
mail@feyyaz.com

editorial project by loft publications
copyright © 2005 loft publications

editor Anja Llorella Oriol
layout Nil Solà Serra
english translation Scott Klaeger
french translation Marion Westerhoff
italian translation Sara Tonelli
spanish translation Almudena Sasiain
copy editing Susana González

printed in spain
Anman Gràfiques del Vallès, Spain
www.anman.com

isbn: 3-937718-53-2
d.l.: B-35969-2005

all rights reserved.
no part of this publication may be reproduced in any manner.